NATURAL
WATERCOLOURS

NATURAL
WATERCOLOURS

Painting From Nature Made Easy

Richard Taylor

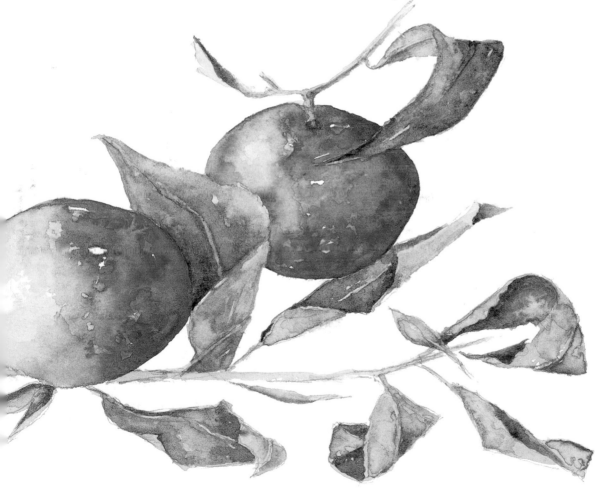

David & Charles

A DAVID & CHARLES BOOK
First published in the UK in 1998
Reprinted 1999, 2002
First paperback edition 2001

A catalogue record for this book is available from the British Library.

ISBN 0 1753 0699 5
ISBN 0 7153 1168 9

Printed in China by C.S. Graphics Shanghai Co, Ltd.
for David & Charles
Brunel House Newton Abbot Devon

CONTENTS

INTRODUCTION

The natural world is awash with subjects for the artist from the simplest flower head to the flowing waters of the mountains and moors, and the fruits of the earth are the staple diet of the watercolour painter.

The central theme of this book is the examination of the colours and techniques used to record natural objects in watercolour, starting with single flower heads, through to groups of objects, eventually moving on to the full-scale landscape. By 'natural objects' I do not necessarily mean only organic objects – the brickwork on a crumbling facade, rust or stains on weathered terracotta pots are all included under the heading of natural subjects as the source of their appeal is the work of nature and the elements.

As well as using step-by-step illustrations and extensive annotations to aid your understanding of the methods that I use in my painting, I have devoted some space to addressing the issues that surround our practice as artists – chiefly the way in which we see and use colour. The colour that we see in our daily lives is entirely the result of reflected light. The paint that we buy from art shops is, largely, created by chemists and manufactured in factories. As artists we have the difficult job of making connections between these two factors, and must accept that there are no exact replicas for nature to be found on art store shelves – neither are there any instant formulas available for reproducing colours found in nature or natural environments.

To compound this, different types of environments create differing atmospheric effects, with the consequence of different qualities of reflected colour. The clarity of air and atmosphere around the Cornish peninsula at the turn of the century made Newlyn and

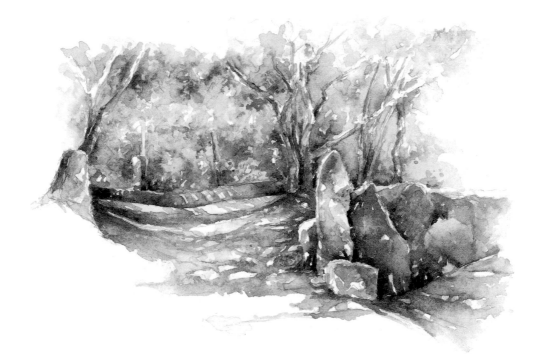

St Ives focal points for artists. The pearl-like quality of light that came from the vast skies and Atlantic Ocean resulted in painters recording a sharpness of colour with enhanced shadows tinged with blue and grey. The fishing ports of the Mediterranean colonised by many French artists during the 1930s, however, resulted in more vibrant paintings as artists worked in the blazing heat of the Côte d'Azure. The intensity of light produced paintings glowing with primary reds, yellows and blues, and shadows soaked with the warmth of violet and orange.

But this, surely, is the appeal of painting. Painting is unique to every individual in every place – each painter needs to find his or her own personal response to the colours that they seek to record. This will involve establishing your own range of colours based upon your own individual needs and preferences.

In this book I offer guidelines for very specific techniques and methods of painting, but not for a specific palette. I only mention those paints that I have settled with after many years of trial and error, but were I to write this in ten years' time, I certainly could not guarantee that they would be the same. As with all artists, progression and development are vital to our very existence.

The main aim of this book is to examine where and how colour occurs naturally, and the ways in which it can be used to its fullest potential. Watercolour is a medium capable of great subtlety and delicacy. It is also capable of intensity and vibrance. But its fullest potential lies in the hands of its exponents.

MATERIALS AND TECHNIQUES

Sap green is no longer made from crushed ripe buckthorn berries — commercial processes have taken over from the medieval alchemists, but an understanding of the origins and principles of the watercolour process is just as valuable as ever.

One of the fundamental principles that underpins all of my teaching is a thorough understanding of your subject, materials and processes. Your ability to work effectively in watercolour will be determined in part by your understanding of the watercolour process.

The 'alchemy' of watercolour painting is, in fact, one of the most straightforward of painting processes. In brief, watercolour paints are made by mixing ground colour pigment with a translucent medium (generally gum arabic).

The coloured pigments that form the basis of watercolour paints manufactured today were, in fact, discovered centuries ago, but rarely appear in commercially available paints any longer. Modern technology has now overtaken the production methods of artists' materials, allowing a wide variety of paints to be marketed at an equally wide variety of prices. Ultramarine, for example, which was originally made from grinding the semi-precious stone lapis lazuli, dug from the Afghan foothills, has been replaced by the synthetic ultramarine which was developed in Paris in the 1820s. Equally, the siennas and ochres which were once dug from the iron-oxide rich volcanic regions of southern Europe are now chemically reproduced without any of the impurities of the original pigments, which makes them considerably more stable and easier to use.

When mixed with water and applied to a paper surface the water is absorbed or evaporates leaving the coloured pigment bound to the paper by the gum. The translucent quality of the colour pigment in gum allows any preparatory drawings or undercoats to remain visible, although they will become more clouded with every subsequent wash. Here lies the key to watercolour painting: light passes through the particles of ground pigment and the medium and is reflected back from the white paper surface. Tinted papers will be less reflective and will produce muted colours, but they do have their uses and are considered in more depth on pages 14–15, and in the last chapter on landscape painting.

This, fundamentally, is the watercolour process. No additional binders, fillers or mediums are required – just a set of paints, a brush and a sheet of watercolour paper. But this, of course, is watercolour painting at its most fundamental. At its most complex, it is a medium of great expression yet great subtlety – it can be bold yet soft and always fluid. There are, naturally, many stages in between the simplicity of the basics and the complexity that the most experienced hand can bring to bear, and most of these will be considered and explained as this book progresses.

You may also find that as your competence in using watercolour paints grows, you become increasingly interested in the alchemy of painting, even eventually going so far as to make your own paints (which is, in fact, a relatively easy process). For now, however, it is time to examine some of the types of watercolour painting equipment available in art stores today.

EQUIPMENT

One of the best things about watercolour painting is the minimal amount of equipment required to produce a picture. A few paints, one brush, a sheet of paper and, of course, some water will suffice. As your need to progress develops, so your choice of equipment will become more sophisticated – but basically it will still be the same – paints, paper and brushes!

Brushes
I use three synthetic brushes – small (size No.1), medium (No.6), and large (No.14) – all with long handles as I like the feeling of balance that these afford

Pan paints
These come in full or half-pan sizes (half-pan are the most popular). Always choose artists' quality whenever possible as these will give you the clearest colours

Watercolour tins
These are invaluable for both on-site and studio work. They contain a mixing lid, usually a central section to hold retractable brushes, and the most expensive models even have built-in water containers. They hold full or half-pan paints, fold up to pocket-size and are, in my opinion, indispensable for the watercolour artist

Tube paints
These paints contain the same pigments as pan paints and are good for creating real strength of colour when used with minimal amounts of water. They are a little cumbersome when working out of doors, however

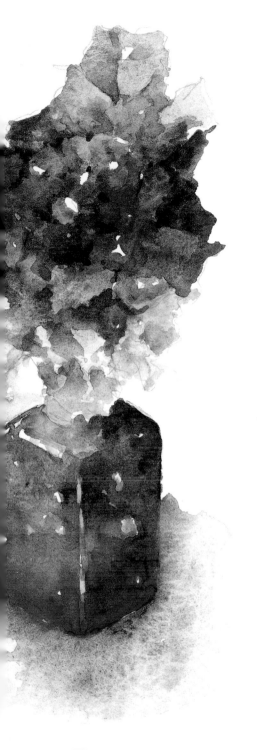

Equipment

There are, throughout the world, many art stores displaying the products of many manufacturers of artists' equipment, some of which can be bewildering to the uninitiated. So, my advice is to keep your choice of equipment simple and transportable. This way you can spend more money on a few items, allowing you to afford quality equipment.

I personally work with nothing more than a set of pan paints contained within a small tin, three brushes, a small plastic water container with a screw lid (you will never need much water, so the smaller the better, within reason) and a hardbacked sketch pad when I am out on expeditions. (This is particularly useful when you are sketching or painting out of doors and it is much easier to carry from site to site than a drawing board and easel.) I also buy the same colours in tubes as I use in my tin as these are excellent for adding depth and 'body' to a picture, and they complement the qualities of pan paints particularly well. However, they stay at home in a large tin as they take up space, roll around in bags and, occasionally, leak. A guide to my personal choice of colours appears on the next page.

The brushes I use are synthetic. They are a more affordable alternative to the traditional sable and, nowadays, run a very close second in terms of water-holding quality and durability.

The only other peripherals that I carry on painting expeditions are a B pencil, a sharpener and a few sheets of kitchen paper towel for blotting water or paint bleeds – a technique which is examined further on in this chapter.

COLOURS

Many paints have names that do not give you much of a clue as to their properties, so it is worthwhile spending some time studying the paints on these pages. Each has something unique to contribute to a watercolour painting, although not every paint featured here will eventually appear in your personal palette.

Colour temperature is a phrase that artists use to describe the overall feel of a colour. We tend to associate oranges and red with heat, and blues and violets with cooler situations. But beware, not all reds are 'hot' colours, and not all blues are 'cool'. This is something which is considered later on in the book, so keep an open mind about colour

Natural colours (mainly the yellows and browns), are those that are dug from the earth. Many have their origins in the volcanic and mineral seams of the Italian hills

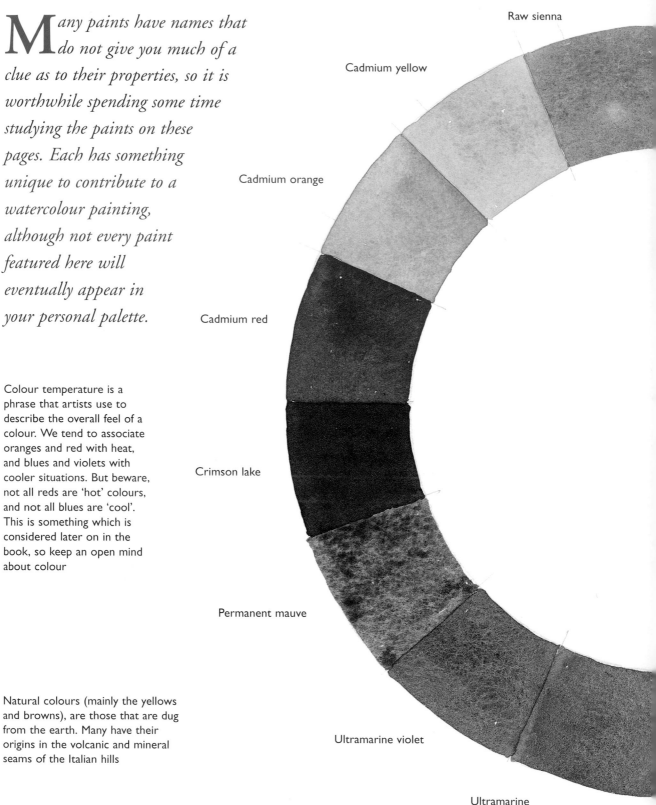

Raw sienna

Cadmium yellow

Cadmium orange

Cadmium red

Crimson lake

Permanent mauve

Ultramarine violet

Ultramarine

My Choice of Colours

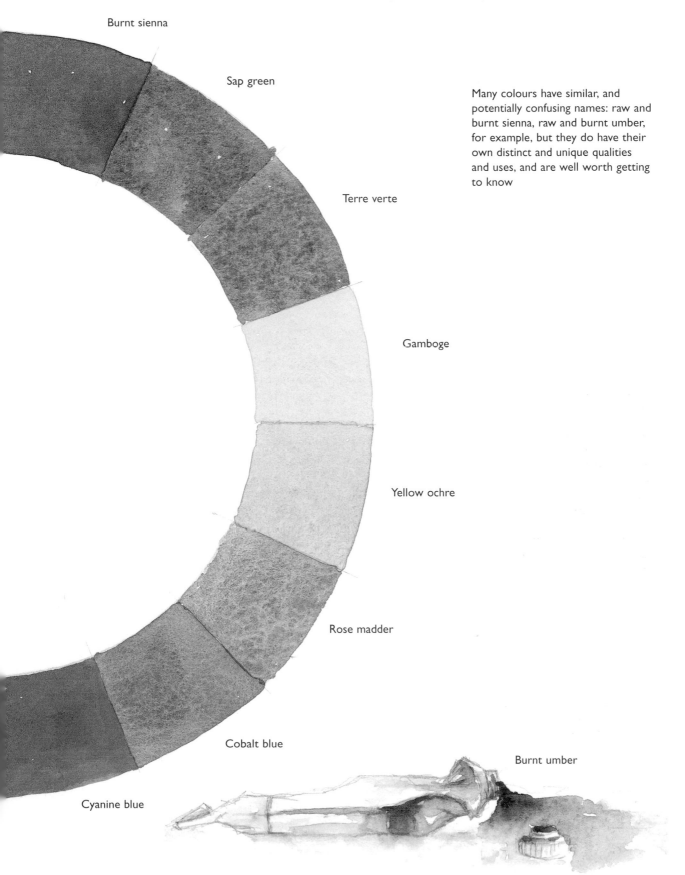

Burnt sienna

Sap green

Terre verte

Gamboge

Yellow ochre

Rose madder

Cobalt blue

Cyanine blue

Burnt umber

Many colours have similar, and potentially confusing names: raw and burnt sienna, raw and burnt umber, for example, but they do have their own distinct and unique qualities and uses, and are well worth getting to know

PAPER

Understanding the qualities of watercolour paper is, I believe, just as important as coming to terms with the qualities of colours and paints. The quality of paper and its type of surface can have a real influence upon the type of painting that you produce, so be prepared to experiment and try a few.

Rough

Oatmeal

Eggshell

Grey

Blue

Paper classification
NOT, OR COLD PRESSED (CP):
a slightly textured, general-purpose paper which comes in a variety of weights
HOT PRESSED, OR SMOOTH:
a smooth, textureless paper which is good for tinted drawings and detailed work
ROUGH: a highly textured paper which will stand up to a lot of punishment

Weight
Paper is classified in pounds (lbs), or in grams per square metre (gsm, or g/m^2). The lighter-weight papers start at 90 lbs (190 gsm), a good middle-weight paper is 200 lbs (425 gsm) and the heavier weights are around 300 lbs (638 gsm)

Watercolour Papers

Certain types of paper will absorb water more quickly than others, giving you less time to create textures or bleeds. Others (the lighter-weight papers) will 'cockle' if flooded too quickly with water or very wet paint. Knowledge of the qualities of the vast range of papers available will eventually come through direct personal experience of their use and, basically, trial and error. In the meantime, however, here is a rough guide:

Most papers of approximately 200 lbs (425 gsm, or 425 g/m^2 – grams per square metre) and over will absorb water at a rate which will allow you to work onto it for a good few minutes at least. This is important as manipulation of watercolour paint can be achieved in several ways, all of which will be examined as the book progresses.

Rough paper gives a surface of broken brush strokes and heavily textured images. Such paper is best suited to expressive brush work, as long as you do not mind the paper taking a little control of your painting.

Smooth paper will allow you to work fluently onto a smooth surface creating soft bleeds. It is particularly well suited to light painting onto pencil drawings or sketches, where the lines made by your pencil or pen will not have scratched the surface of the paper.

Tinted paper has its value, but this is limited, especially for subjects where the white of non-tinted paper is often used.

Watercolour paper is sold in many different forms – loose sheets which are good for studio work, blocks (loose sheets bound together at the edges) which are much more transportable but still loose when separated, and, my favourite, sketchpads.

I prefer to use a ringbound, hardbacked A2 size sketchpad because the paper is large enough to allow me to make some strong, expressive lines and washes yet it is easily transportable. Also the hardback binding of the sketchpad gives support when working outside, travelling from site to site to paint your chosen subjects.

SKETCHBOOK STUDIES

Sketchbooks are the lifeblood of most artists. They allow you to make a quick, spontaneous response to anything you see, anywhere and at any time, and that response is kept as a reference to be used at a later date when your visual memory needs a prompt.

Landscapes comprise many parts, all of which combine to make up the complete scene. Equally, a bunch of flowers is composed of several parts: the stems, leaves, petals, all of which together make the bunch look appealing. I, personally, have always found that making studies of the component parts of a scene is a good way of getting to know exactly what colours to use and what sort of shapes to suggest. In fact, I will often become so engrossed in making studies that the scene itself becomes unimportant, and the studies take over as pieces of art in their own right. Why not? If an object possesses colour and shapes that are attractive, then they are worthy of a painter's time.

Personally, I cannot recommend too strongly making studies of objects. This allows you to understand your subject – its colours, its structure and its shape, and to familiarise yourself with your subject before you tackle it for the first time.

Studies do not need to be confined to the small postcard-size sketchbooks that fit so conveniently into a pocket, although these are a valuable asset for any painter to have. Studies of objects can be undertaken on a large scale, often around the edge of the paper that you intend to work onto. In fact, they may very well become an integral part of your overall page.

My reason for making studies of subjects is to get to know them well before I attempt to use them in a composition. Painters constantly make decisions as they work – which yellow to add, how

much water to add, what colour to use as a background, and so on. If your decisions can be based on knowledge of your subject, then the chances are that they will be the right decisions.

OBSERVATION

Having chosen a subject to study I tend to employ the following techniques. Firstly I pick up the object and look at it from lots of different angles (unless, of course, the subject is alive and growing in someone else's garden). I will then, in the case of flowers, see if I can count the number of petals and note any geometric structure. In the case of leaves I look to see if the veins appear as positive or negative shapes. I will then look at the back of the subject and the sides, trying to find the most visually interesting aspects to record. I then sketch the shapes using a B grade pencil.

Colour is the next aspect to observe. Many decisions need to be made about choices of colour, so the fewer colours you have to choose from, the easier this becomes. I will start most colour sketches of natural objects with a light underwash and apply the main bulk of colour (having made the decision about which colour to use by very close observation) while the paper is still damp. This allows the paints to bleed gently together, creating a natural flow of colour, as experience tells me that colours rarely have sharp, clearly defined boundaries in flowers and foliage.

I believe the appeal of recording shapes observed from natural objects and applying watercolour paint freely is in letting the paint blend and bleed its way across the paper, in and around the flower heads, therefore creating its own variety of colours and tones as it dries. In short, record the shapes accurately in pencil, then simply let the colour work for you.

Underwashes often serve as the negative shapes when painting leaves and petals

A good underwash will influence the appearance of all colours that are laid on top of it. A warm under-wash will enhance the colour temperature of yellows and reds

Sketchbook Study of Branch and Leaves

A subject as simple as a branch carrying a few leaves can provide a wealth of colours, tones, textures and skills to practise. They are as easily available in the wild as they are in towns and cities.

The twisting, curling shapes of fresh leaves makes them a pleasure to draw; the older and more decayed leaves are, then the more interesting they become to paint. The line of the branch and its leaves made it ideal to record diagonally across a sketchbook page, using a B pencil to make the initial sketch. This arrangement also allows you plenty of room in the corners of your page to make any notes you wish on the colours you choose to mix or the colours you have seen.

A limited range of pigments has achieved a wide range of warm and soft tones. The main colours used were crimson lake,

cadmium red, cadmium orange, raw sienna and sap green, with a few additional colours to add weight to the darker tones.

This painting was made quite spontaneously. The leaves were not treated to a planned and considered build-up of washes as you might expect with a landscape painting. They were, in fact, treated to one basic underwash to enable the 'negative' shapes to be developed. From there on I sought to mix the strongest, most vibrant colours that I could and, having mixed these in my palette lid, applied them to the leaves in the knowledge that the underwash that I had chosen (a warm mixture of raw sienna and cadmium orange), would react with the newly applied paint to underpin the strength and enhance its vibrance. For this is the key to watercolour painting as mentioned on page 9. The translucency of the paints always allows the underwash to show through and, as your experience grows, you will learn to use this to your advantage.

The leaves opposite are a particularly good example of the warm undercoat enhancing and lightening the colour temperature of the crimson lake, the cadmium orange and the cadmium red.

Much of this painting was completed on damp paper. The underwash was applied to a dampened surface and, before this had time to dry fully, the bulk of the paint was applied, allowing the colours to bleed gently and fluidly. This is most frequently referred to as 'wet-into-wet' (see pages 32–33) even if the paper is in fact only damp and not flooded with water.

The golden-orange coloured leaves were created by mixing raw sienna with cadmium orange and a touch of crimson lake

The deep reds were created by mixing crimson lake with cadmium red and a touch of ultramarine for the darkest tones

Conkers and Casings – A Sketchbook Page

Sketchbook studies have many
purposes: experimentation, quick
recording for future reference, or
simply practising drawing, sketching and
colour mixing skills, all of which are
both valuable and necessary

The veins in the leaves
were painted using the
fine tip of a small brush
dipped into a dark wash
of sap green

Burnt sienna added
to tip of leaf

Raw sienna underwash

It was no surprise to discover that
the colours of the leaves were the
same as those of the seed casings:
sap green, raw sienna, burnt sienna
and burnt umber

These horse chestnut shells picked up from the grounds of my local park proved to be excellent subjects for studies. Seed heads, gourds and wild fruits can often be found in varied stages of openness and decay and making visual notes about these helps to develop your observational skills as well as allowing you to practise colour mixing and painting on a small scale.

Highlights created by blotting the inner section with kitchen roll while the paint was still damp

Darkest tones created by the addition of ultramarine to burnt umber

Sap green was used here as the main colour, painted onto a base of raw sienna

The recording of these three shells required little time, but some concentrated observation and delicate drawing. The various light tones contained within the inner fleshy section were painted by using only the slightest touch of paint and a lot of clear water. By way of contrast, the actual seed was painted with an intense mixture of burnt umber with ultramarine added to achieve the darkest tones. The rough, weatherbeaten, rotting textures on the outside of the seed casings were created by

dropping a little watery burnt sienna paint onto a sap green wash and allowing the paint to separate and dry with a patchy appearance.

This set of studies involved both the 'dry brush' technique (pages 30–31) and the use of 'wet-into-wet' technique (pages 32–33), which was used for the study of leaves on pages 18–19. Very few paintings will be completed using one particular technique alone, so it is a good idea to practise as wide a variety of styles as possible.

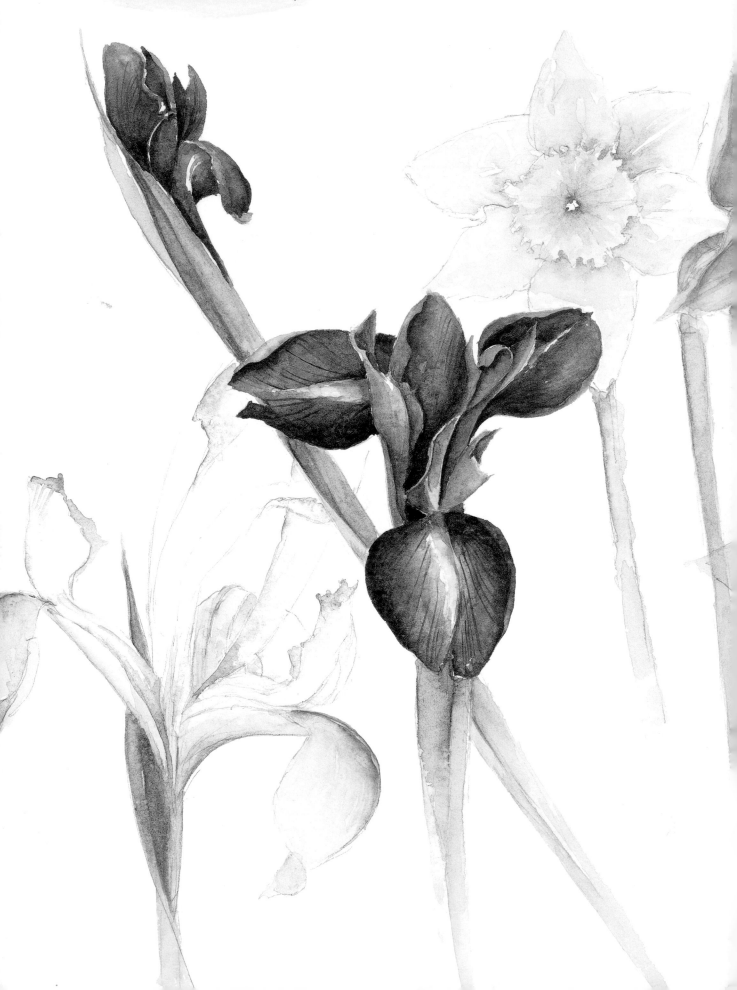

Sketchbook Studies of Garden Flowers

These flowers were all
sketched in a garden one
morning and recorded for
future reference

BASIC TECHNIQUES

The basic methods of applying watercolour paint to paper can be taught and learned, but not as restrictive practices. Techniques should be thought of as developing practices that you will personalise and make your own as you progress.

The watercolour medium is one of the few artistic media that has a limited (although not necessarily restrictive) range of techniques. Basically, paint is applied to paper using water as the medium and that is all there is to it. Of course, the way in which the water is applied – dripped, washed, splattered, dragged, and so on – is another matter altogether. Then there is the consideration of paint: how thick or thin might your applications be and what type of paper will you be working on? A thick textured paper with intense applications of paint will respond very differently from a thin, pale wash of paint on a particularly smooth paper. Another issue here is whether you leave the paints to dry naturally or do you intervene in the drying process, and if you do, would you use a sponge for a smooth effect or a piece of textured kitchen roll for a rough effect? So, with watercolour painting, there are many variations of techniques for you to experiment with, and I strongly recommend that you do experiment as it is only through trying different techniques that you will find the styles that really suit you and that will allow you to achieve the pictorial results that you want.

The next few pages deal with the most fundamental of techniques – these are essential for success, and are certainly worth devoting a little time to practising. Firstly comes the idea of analysis through observation. I vehemently believe that it is only artists who know how to *see* their surrounding world – that is because we are the only ones who really *look* at it. An understanding of your subject will only come through looking inside it, around it and underneath it. You may not necessarily paint all of these views, but looking and seeing them will take little of your time.

The application of paint is then considered. The fewer washes that you can use, the more vibrant and translucent your colours will

be. Each wash will create a thin layer of translucent paint over the layer of paint underneath. At times this is desirable and I actively promote the use of an underwash to help to establish the colours that are subsequently applied as one will invariably influence the other. However, this technique should be limited to one or two washes only. Add more paint to create shadows and detail by all means, but do not wash over colours with other colours time after time as, eventually, it will all turn muddy, and the beauty of the watercolour medium will be lost.

The way in which you apply paint is important. The two main techniques considered are the *dry brush* and *wet-into-wet* techniques. These are not the only two techniques available to the watercolour artist and few painters will restrict themselves to using one technique exclusively. Neither do the demonstrations serve to isolate the techniques. They are, simply, methods of applying paint to paper and can be mixed and matched, extended and transformed into whatever you wish to make them.

The final consideration here is about mark-making. How much do you draw with a pencil, and how much will be free-hand painting? My advice as you are starting out is to use as many guidelines as you feel comfortable with, especially as so many natural objects have their origins in geometrical shapes or have easily recognisable patterns. This makes it all the more easy for you to make a few lines with a pencil to show you exactly where the objects are that you want to leave light, paint around completely, or just to allow you to compose the picture or studies on your page. As your skills develop, maybe your brush will take the place of your pencil and you will begin to *draw* in paint. But there again, maybe you will be like me and always enjoy the act of drawing as well as that of free-flowing painting.

These are a few personal thoughts on watercolour painting techniques. The one constantly recurring point is, however, that none of the techniques should be restrictive. Once you have tried one, then introduce part of another and keep on experimenting until you have an entire range of techniques and skills that you can call your own.

ANALYSIS

Having mastered the skills of observing and recording individual objects, the next stage is to move on to the skill of analysis. This involves pulling objects apart, looking inside, outside, examining them from different angles and looking closely at the physical structure and colour. How, exactly, is it all held together?

Fresh flowers need not be your only choice of subject. As flowers age and start to decay, so their colours and shapes change, providing what can often be a more visually interesting subject

Look inside your subject as well as outside. An understanding of the physical make-up of your subject makes it easier to record

Do not be concerned with always having to produce a finished piece of artwork for framing and display. The processes that go into making the picture – the sketches and analytical studies – can often be of more value to you as an artist

For the artist, analysis means understanding, not to be confused with the scientist's concern for total accuracy. You can be analytical in your studies while still letting the paint flow freely

Analytical Studies of Tulips

Analytical studies can, and indeed should, be experimental – any exercise in enquiry is a potential voyage of discovery, especially for the artist. You may find it a worthwhile exercise to chart the progress of a natural object from opening (in the case of buds or shells) through to drying out and decaying. You may also wish to examine the best technique for recording objects at different stages of their development. Drawing may hold the key to recording the more intricate details of a pine cone, whereas free-flowing paint may give you a better understanding of the way in which colours blend naturally in leaves.

Colour variation within a species can emphasise the different tonal values of colours, highlighted when two flowers are placed next to one another

Leaves have a top and an underside, which are generally different in tone

Studies are invaluable in helping you to sort out the best way of painting these colours before putting them together in a composition

BUILDING UP WASHES

The first application of paint shown here was a thin wash of gamboge (yellow) which established the overall tone of the painting

The watercolour technique is based on the principle of building up layers of paint through successive washes. This allows the translucent quality of the watercolour paint to work for itself as each colour reacts with the previously applied paint.

The first wash to be applied is usually referred to as an *underwash* or *undercoat*. This should always be a thin, watery wash that will help to establish the overall tone of the subject. In the illustration of the tulips shown here I chose gamboge (yellow) as the first wash for its fresh, spring-like qualities which I felt particularly suited the subject matter. I applied the wash freely with a large brush.

Cadmium orange was painted over the gamboge wash to block in the colour

Tulips

The shadows shown here were created by adding a touch of ultramarine to both the petals and the leaves

The next stage was to establish the individual colours, applying these to the leaves and tulip heads with the same large brush I used for the underwash. This is called *blocking in* and can be applied to a wet undercoat to good effect. Working onto damp paper will allow the paint to spread and flow fluently, and will dry to an uneven but natural finish. Blocking in the colours will often leave the subject looking flat, so you will then need to apply a further wash to establish detail.

The final stage here was to mix the deepest, darkest tones and create the shadows by applying these to the undersides of the leaves and inside the petals. I used a smaller brush to do this to allow more control over the paint. Adding this detail introduces form into the picture, suggesting that your subject has a back, front and sides, and that you could put your hand behind it and lift it from the paper.

DRY BRUSH TECHNIQUE

*S*ometimes you will see a subject that you wish to record in watercolour but feel that you need to work in soft, muted tones and that, actually, all you really want to do is to tint a drawing. That is where the technique examined on these pages becomes invaluable.

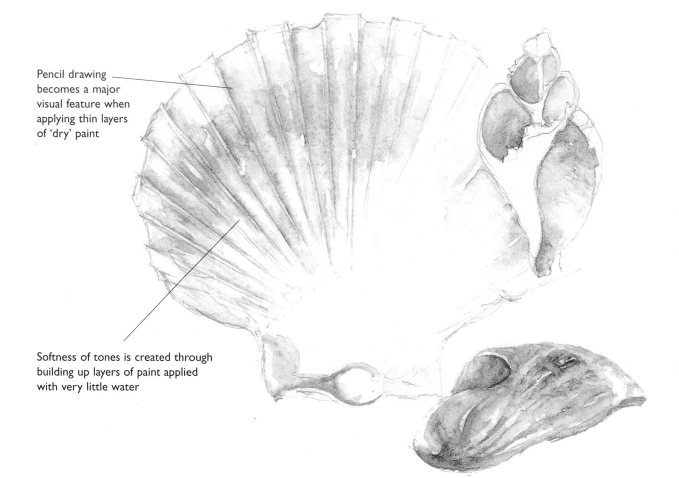

Pencil drawing becomes a major visual feature when applying thin layers of 'dry' paint

Softness of tones is created through building up layers of paint applied with very little water

Dry brush is a term that is not to be taken too literally – although it does make some sense, as you will discover when you start to practise it. The technique involves using minimal amounts of water in your application of paint. It is best used when you require a soft, subtle range of tones and where you want to maintain total control over your application of paint. For this reason it is often, although not exclusively, best practised on the smoother papers described on pages 14–15. The build-up of several dry washes onto dried paper gives this technique its title. It is a technique which is also best restricted to use with pan paints, as the strength and body of tube paints can give much too strong a finish. It is, in brief, more of a tinting process where the drawing will be the most prominent feature.

Sea Shells

Pencil work will often become the
principal feature of this type of study
and often acts as a structure on
which to work with soft, subtle paints

Shadows and depth of tone
are best achieved through
choice of colour rather than
strength of paint

Natural objects with linear patterns
are well-suited to pencil drawing
and thin applications of paint using
the dry brush technique

WET-INTO-WET TECHNIQUE

This is a texture technique – wild, rough, free and unpredictable until you learn to establish some control over it. It is a technique that sometimes involves a little courage, but one that can provide some stunning effects once mastered.

The mottled texture on the crab shell is the result of the natural separation of colour on rough paper

Textures on the crab shell are created by many applications of wet paint onto wet paper, allowing the colours and tones to mix naturally, and to bleed freely

A background tone is created by dropping water onto wet paint and allowing it to bleed freely. This is a good technique to use when you wish to create a background tone behind a particularly light object

This very expressive technique removes a lot of control from your paint brush and leaves much to chance, but you can assert a certain level of influence over it, by intervening with a scrunched-up piece of kitchen roll to dab or mop up any bleeds which are getting out of control.

As the name implies, the wet-into-wet technique involves adding wet paint to wet paper. As this happens, the wet paint will mix and bleed, finding its own way across the paper and will dry with a patchy, tex-tured result, occasionally aided by a deft dab with the kitchen roll.

Crab

You can apply wet paint to wet paint to create colour bleeds, or wet paint to wet paper (wetted with clear water only) which will allow paint to fade out, or for light, irregularly toned backgrounds.

This technique requires strong, heavyweight paper to support a lot of very watery washes, but it is great fun to experiment with and will remove the inhibition of working strictly within set pencil lines.

BASIC SHAPES

*M*any natural objects can be drawn using simple geometric shapes as a starting point. You will find that spheres and cones are the shapes that form the basis of most natural objects such as flower heads, fruit and berries.

One particularly good exercise for learning how to draw subjects based on spheres is to find several objects that share the same spherical shape and sketch them from several different angles, using the stems as the axes. Look for their shaded sides and paint these in the darkest tone then, using clear water, *pull* the paint around the shapes to create graduated shading. To achieve the shaded effect place the tip of a wet brush onto the damp paint and literally pull the brush down and around the shapes. The damp paint will be picked up by the clear water and will flow in the direction of your brush stroke, gradually becoming fainter as it dissolves in the water. This method will ensure realistic, three-dimensional shapes like the illustrations shown on this page.

Highlights have been created by blotting with kitchen roll while the paint was still wet

Raw sienna was used as an underwash to create a feeling of warmth

Shape was given to these seed heads by following the lines of the indents with a very fine brush loaded with a mixture of all the colours used, mixed together on my palette

Burnt umber wash used to create the dark tones of the shadows

Burnt sienna and cadmium orange were combined to create this rich colour

Rosehips

Conical shapes are equally valuable to practise – but be sure to look inside the 'trumpet' shapes of flowers as they are normally darker in the furthest parts where light does not penetrate as freely. Some other shapes to use for constructing natural forms are cylinders, which are the basis for daffodils, and spirals, which can be used for sea shells. Both are worth practising. However, the main shapes will usually be spheres and cones.

Lilies

Foxgloves

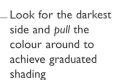

Look for the darkest side and *pull* the colour around to achieve graduated shading

The insides of cones are usually darker – use less water to create an intensity of tone

Conical shapes form the basis for many flowers and plants

NATURE INDOORS

The comfort and stability of your own home is by far the best place to start watercolour painting – you know exactly where and when you can paint, and can set up any objects you choose according to the time you allow yourself.

One of the best places to start experimenting with watercolour painting is certainly in the privacy of your own home. This chapter deals with how to set about recording objects (single and groups) that you have either picked from your garden, found on forest floors, or brought home from shops or markets. My reason for choosing the objects featured in this chapter has usually been the attraction of their colours – simple plants that have caught my eye, seafood on a waterfront stall, or a simple iris head. All contain a wealth of colour and all are good starting points for watercolour recording.

The materials required for working indoors are simple – a small watercolour tin set, one or two brushes and a few sheets of watercolour paper are all that you really need. Additional items such as kitchen roll for blotting and a small glass jar for holding water are commonplace in most homes.

The other great advantage of working indoors is the constancy of both weather and lighting conditions – although a word of warning here: any type of artificial lighting will affect the way that your colours will look. It is not unusual for students working on a painting under fluorescent lighting during the evening to be very surprised when they view their work in natural daylight the next morning – the colour balance often looks quite different. So, whenever possible, sit near to a window or the nearest natural light source that you can find. Many people nowadays take advantage of daylight bulbs, which come close to the effect of natural light.

Organisation of equipment is also important, the most important being support for yourself and the surface on which you are working. If you are perched on the edge of a soft, sinking seat with your pad balanced on your knee, the chances are that you will want to shift your position from time to time as your back stiffens or, more predictably, the telephone rings. This will mean that your viewpoint of an object will change with you as you rise, or will change angle when you sit down again. This does not make life easy when you are drawing a group of objects as the balance between the interplay of shapes is vital. So it is best to ensure that, whenever possible, both your subject and your paper or pad are both resting on the same surface, preferably one that will not easily move (a large solid table, for instance), so that even if you have to move, you will return to the same viewpoint and the position of your subject and your paper will remain constant.

Finally, it is worth mentioning that absolutely anything can be a suitable subject for indoor painting. The most seemingly uninspiring objects, such as vegetables, can prove to contain a wealth of visually fascinating sources. A partially peeled onion can provide an array of subtle tones and shapes, all within the same colour base. A dissected pepper contains an amazing feast of shapes and richness of colour. Place a red pepper and a green pepper together and your watercolour palette will be smouldering for hours! These everyday household commodities are a part of nature's rich and varied harvest and they provide excellent subjects for sketching and on which to develop your watercolour techniques.

So, having set up an object that you wish to paint, exactly how do you start? In the early stages as a watercolour painter, I strongly suggest that you make a few visual notes, or sketches, maybe around the edge of your paper, of the key components or shapes of your

subject. This serves several purposes, but chiefly it helps you to get to know your subject before you set about painting the full sheet. Having settled on a few good shapes, experiment with colours. Mix the colours that you feel are correct in your palette and try this on your sketches, bearing in mind that one of the qualities of water-colour paints is that they dry to a considerably lighter tone on paper than they appear on your palette when wet.

Having satisfied yourself that the sketches and colours have given you an adequate insight into the nature of your subject, it should be time to commit yourself to drawing the basic shape of your subject, usually with a B grade pencil. You need not complete a full outline of your subject, as this will result in merely filling in blocks of shape with colour, and watercolour should be a little more free-flowing than this. Watercolour painting should never be restrictive. Just a few pencil lines or marks denoting the position of key parts within your subject is really all that you need. The next thing to do is to make sure that you feel comfortable with your paints. You should not have to reach to get your equipment – have it all ready at hand.

It is then just a question of re-mixing the colour combinations that you found successful in your studies, and applying these to your paper, just as the following demonstrations illustrate.

Apple Harvest

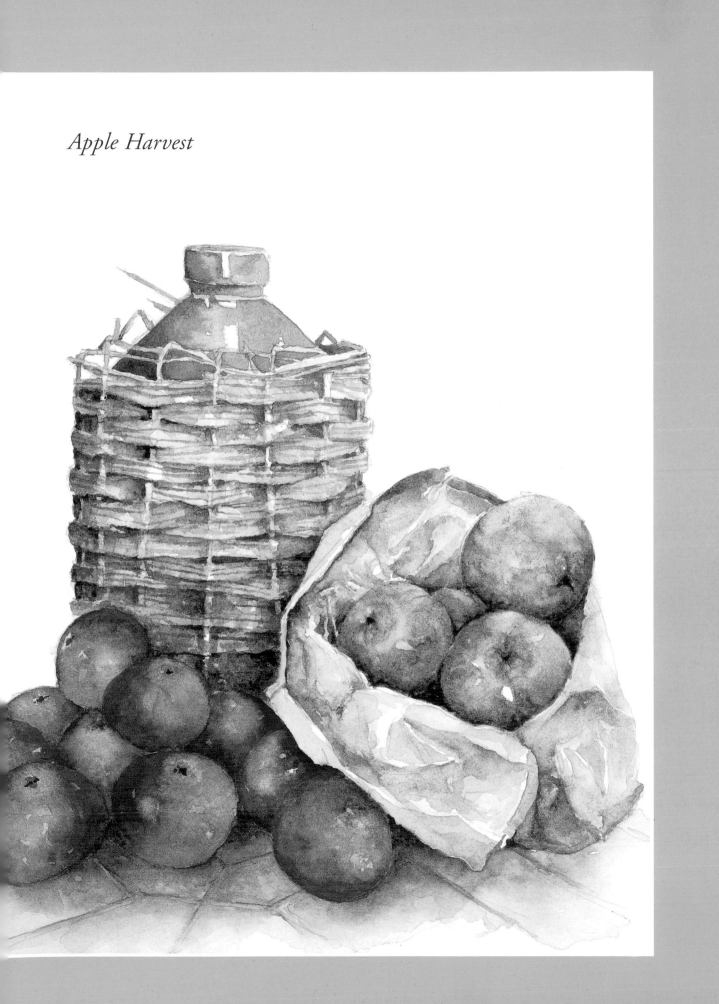

FLOWER HEADS

*Y*our first foray into the world of painting natural objects using
watercolour will be most successful if you choose an easily accessible
subject, quite small and with a limited colour range. For this reason I have
chosen a few almost monochrome flowers to start off with.

Permanent mauve

Ultramarine

Cadmium orange

The first stage of this painting involved choosing two colours which are natural allies – ultramarine and permanent mauve, both paints having a warm blue base. Having mixed the two colours in the lid of my tin, the paint was washed onto dry paper using a medium brush, pulling the paint towards the centre of the flowers where an accumulation of paint will always dry to a darker tone. This characteristic of the paint is a useful one to learn to control: a deep, strong tone can always be produced when a puddle of paint forms on dry paper. The water will eventually evaporate, leaving an intense layer of pigment.

The colouring around the centre of the flower head and the shading that separates the individual leaves was created by intensifying the strength of the paint rather than the addition of any other colours (more paint, less water). This thicker,

stronger mixture of ultramarine and permanent mauve was added while the first undercoat was still wet. This time, the paint was applied to the centre, pulling outwards with the brush to create the effect of diffused colour. Working onto damp paper in this manner is common practice for watercolour painters wishing to achieve graduated tones as paint added to wet or damp paper will always bleed to a greater or lesser extent.

When the second wash has dried you may find it necessary to highlight the distinction between the petals by running a fine line of paint along the line of the shadow and dropping a little water onto this. This is best done with a small brush, just using the wet tip. Some paint will then spread and bleed with the water and some will dry naturally, reinforcing the irregularity of natural shadows.

Random studies of flower heads on a sheet of paper or sketchpad are of as much value (if not more) as a finished painting as they provide you with information and references

The back, or underside of petals and leaves will often be a lighter tone than the front

The deepest tones are created by dropping dark paint onto dry paper and pulling the paint outwards

It is always a good idea to study the backs of flowers as well as their fronts. Apart from giving you a better insight into their structure, they can also look equally appealing

Sketchbook Page of Flower Studies

IRISES

Irises are elegant flowers – both the petals and stems are long and slender and will always look good on a sketchbook page.

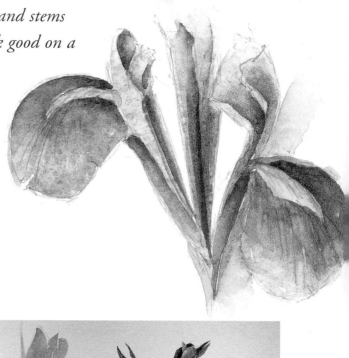

The graceful form of the iris lends itself to freehand sketching – long flowing lines and clearly defined shapes. I always like to select a bunch in varying stages of openness as this allows me to explore the wealth of shapes for alternative views. The tight, closed stem can be as visually interesting as the faded flower when the petals start drying out and begin to droop.

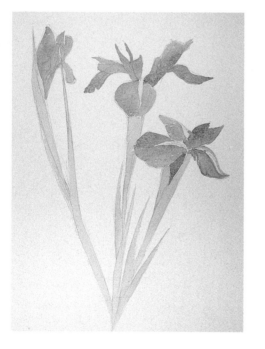

1 Having drawn out the shapes of the iris heads, the lightest tone visible in the petals was mixed with ultramarine and permanent mauve and washed onto dry paper with a loaded medium brush (No.6). The stems were then treated in the same way with a mixture of sap green with the slightest touch of ultramarine. This undercoat was used in the next stage to create the parts of the petals and stems caught by the light.

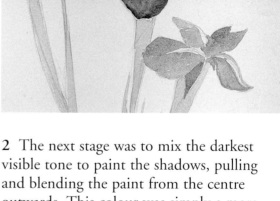

2 The next stage was to mix the darkest visible tone to paint the shadows, pulling and blending the paint from the centre outwards. This colour was simply a more intense version of the first wash; less water was added, diluting the paint less, allowing the natural strength of the colour to show through. When the paper was dry, some of the shadows were reinforced by painting along their edges with a small brush and allowing the paint to dry without any bleeds to add to the intensity of the tone.

Irises

It is always a
valuable exercise
to make a study
of a single leaf.
This will give you
a good insight
into the colours
to use, and also
how much water
to use

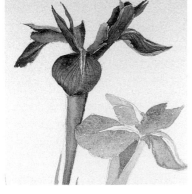

3 The final stage was to add the flashes of
yellow that run the length of the iris petals.
These were added using the same small
brush. The edges of these yellow strips
(painted with cadmium yellow) were then
allowed to bleed gently outwards by the
addition of a little water to the sides,
creating the gradual change of tone from
strong yellow to near creamy white.

Where petals twist
and curl highlights and
shadows will occur.
These shadows are
best painted with a
small brush onto dry
paper, using a little
water. This means that
the paint will not bleed
and will dry to a more
intense tone. The
highlights will then
look after themselves

LEAVES

*L*eaves are not always green and it is sometimes worth waiting for *the changes in the seasons to observe some of the most visually striking colours to be found on the forest floor.*

The leaves on these pages were all painted using the wet-into-wet technique (or, at least, wet-into-*damp*), examined on pages 32–33, in order to achieve the subtle blends that so often occur in nature. One of the most rewarding aspects of watercolour painting can be dropping wet paint onto freshly painted damp paper and watching it bleed, blend and create a wealth of tones with or without your intervention.

The veins in many of these leaves were created by using the first undercoat to represent the lightest part of the leaf (the same principles as the irises). The skeletal 'negative' vein shapes were created by painting the darker tones and colours around them.

The positive vein shapes here were painted onto dry paper. A more intense mixture of the orange used for the bulk of the leaves was mixed and applied with a small brush. It would not have been wise to have attempted to include every vein, so an element of selection was required. I selected the major veins, ignoring the minor ones.

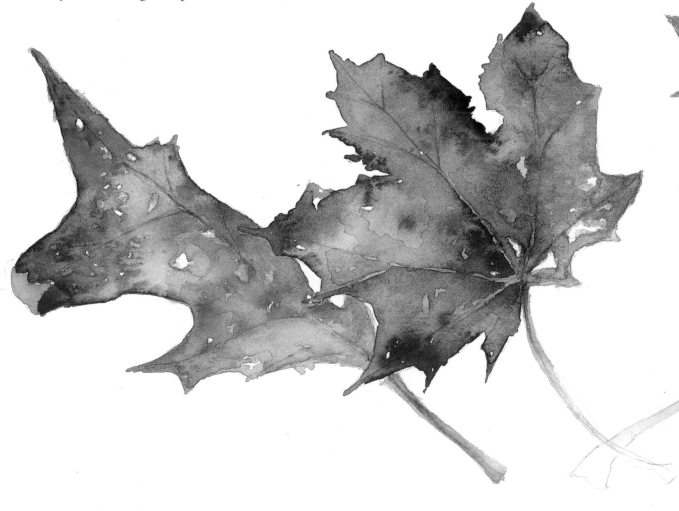

Sketchbook Studies of Leaves from the Forest Floor

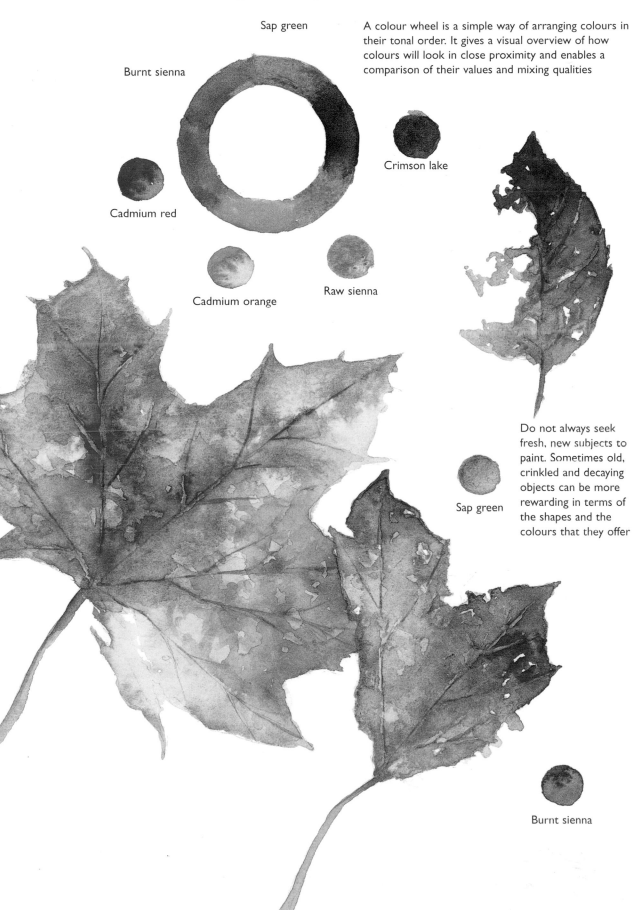

Sap green

Burnt sienna

A colour wheel is a simple way of arranging colours in their tonal order. It gives a visual overview of how colours will look in close proximity and enables a comparison of their values and mixing qualities

Crimson lake

Cadmium red

Cadmium orange

Raw sienna

Do not always seek fresh, new subjects to paint. Sometimes old, crinkled and decaying objects can be more rewarding in terms of the shapes and the colours that they offer

Sap green

Burnt sienna

VINE LEAVES

Leaves usually act as a microcosm of the seasons in terms of the colours that they hold and are, therefore, valuable starting points in assessing which colours to choose for a particular scene. Just a small section of this richly coloured grape vine gave me all the information about the colours of the vineyard that I would ever need – warm, deep reds, golden oranges and soft greens.

The colour blends and textures on these leaves were created by washing and blotting in rapid succession (that is, by applying a lot of watery paint and occasionally blotting out sections with a piece of kitchen roll)

Fruits of the Vineyard

Most of this study was painted with a medium brush, a limited range of paints (chiefly raw sienna, burnt sienna, cadmium orange, cadmium red and sap green) and a lot of water

Sap green with a hint of ultramarine was used to create the darkened section against which the underside of the leaf can clearly be seen

Cadmium red and burnt sienna mixed together here add a heightened sense of warmth

Leaves become more interesting as they begin to dry out. They lose their natural symmetry and begin to contract and crack as they become increasingly brittle. As the leaves fold over on themselves, so the underside becomes more visible and a whole new challenge begins – distinguishing between the lighter tone of the underside and the more distinct tones of the top of the leaf. This is best achieved by enhancing the shadows directly underneath the fold, creating a clear and positive distinction between the two sides. The sharpness of a clearly defined shadow adds to the effect of the fragility of these leaves as they begin to wither on the vine.

AUTUMN FRUITS

*I*t is always advisable to consider different views and angles of individual objects in the hope of finding a better viewpoint. Sometimes it can be interesting to dissect objects, as they often contain more intricate and complex shapes and colours inside than you will find on the protective outer skin.

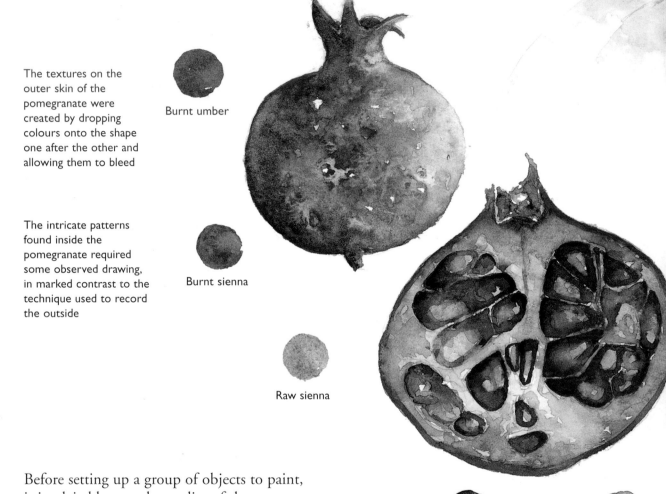

The textures on the outer skin of the pomegranate were created by dropping colours onto the shape one after the other and allowing them to bleed

Burnt umber

The intricate patterns found inside the pomegranate required some observed drawing, in marked contrast to the technique used to record the outside

Burnt sienna

Raw sienna

Crimson lake

Cadmium orange

Before setting up a group of objects to paint, it is advisable to make studies of these individually as well as collectively (see the following pages). When first starting to group together objects to paint it is best to choose subjects that have a similar colour base (for instance, reds and oranges, or greens), as this makes for greater ease of mixing, especially when it comes to shadows. This will be explored later on in this exercise.

All of the objects chosen here share a base colour of yellow, but of course there are many yellows available. To solve this problem, I have chosen predominantly warm colours to paint these objects: chiefly raw sienna and cadmium orange, using burnt sienna and burnt umber to create the darker tones and shadows.

Studies of Pomegranates and Pumpkins

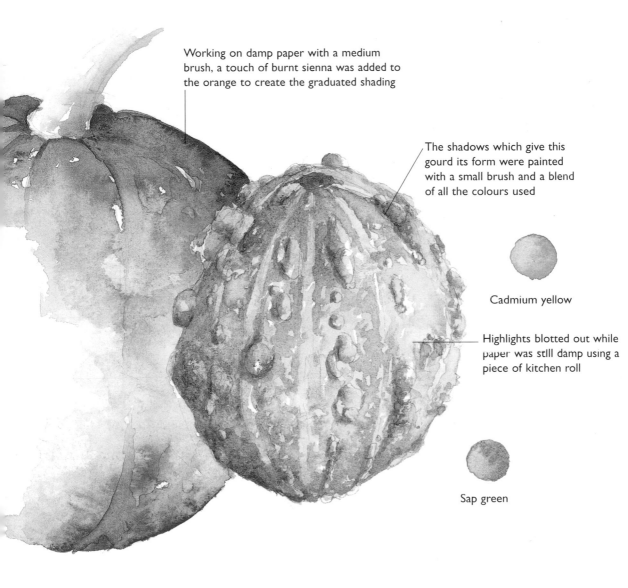

Working on damp paper with a medium brush, a touch of burnt sienna was added to the orange to create the graduated shading

The shadows which give this gourd its form were painted with a small brush and a blend of all the colours used

Cadmium yellow

Highlights blotted out while paper was still damp using a piece of kitchen roll

Sap green

It is particularly useful to become acquainted with the types of reds, browns, greens etc. that need to be used to suggest 'hot' or 'cold' feelings. Here are some personal observations on the qualities of the colours chosen:

BURNT UMBER is a warm, voluptuous colour which is invaluable for creating dark shadows on natural objects.

RAW SIENNA is a hot colour which, when added to reds or oranges, helps to control their vibrancy.

CADMIUM YELLOW is a strong yellow that can appear to give a cold effect to pictures, especially when diluted. The addition of cadmium orange, however, really brings this colour to life.

SAP GREEN is a thin, mid-green which is universally useful in both landscape and individual object painting.

BURNT SIENNA is a reddish brick colour which mixes well with all other colours and is particularly good when used for shadows and shading.

A few quick pencil lines,
with just a dash of paint
(mainly in the shaded
areas) will help you to
establish the positions that
suit you best

Concentrate on the shaded areas
of sketches. The highlights will
take care of themselves and give
you a feeling of form

It is always wise to examine alternatives.
The sketches on this page show the way in
which I tried three different ways of
grouping these fruits together. Any one
would have suited, but I preferred the
balance of the main group featured here.
A few minutes sketching is time well spent.
It helps you to familiarise yourself with your
subject, and allows you to make some
mistakes and to learn from them.

My main interest was the way in which the lighting fell on this group. In this example, the shadow on the pumpkin was painted with some raw sienna (which was prominent in the pomegranate). This raw sienna was mixed with a little burnt umber to create the dark tone of the shadow cast onto the pumpkin. (Shadows are always coloured and never black.) The shadow was painted onto a damp underwash of cadmium yellow and cadmium orange using a medium-sized brush around the back and bottom of the pumpkin and then washed into the rest of the underwash using the same brush and just a small amount of clear water without any paint.

The shadow on the table surface on which the objects were placed was created by mixing all of the colours together in the lid of my paint tin, creating a nondescript yet warm grey. This colour was then applied to the base area underneath the group using a lot of water and, again, the same medium-size brush. An initial wash was applied and, just as this had nearly dried, a slightly more intense version of this mixture of colours was dropped onto the area directly underneath the objects to enhance the sense of shading.

LOBSTER

The main attraction of this lobster was its wonderfully vibrant colours – reds, oranges and crimsons made it glow on the fish market stall. I brought it home to paint, not just for its aesthetic qualities, but to remind me of the vibrancy of the market and the sights and smells that this one object seemed to typify.

The primary reason for choosing a lobster as a subject for a watercolour painting was that the outer shell was ideal for experimenting with the wet-into-wet technique introduced on pages 32–33 while maintaining the wonderfully rich colours of this crustacean. But it was not just the colours and textures. The angular shapes of the jointed legs, and the weight and strength of the nippers set off against a beautifully curved shell all contributed to the visual appeal of this particular subject.

As always, I made a few trial sketches to begin with (seen at the bottom of this page).

These allowed me the opportunity to get the feel for the shapes and colours as well as working through any difficulties that drawing this peculiarly shaped object may bring. It also helped me to make a decision about the exact angle and position that I would use when it came to creating the actual painting.

Overall, the lobster proved to be an excellent subject for watercolour. A build-up of washes eventually allowed the tones and colours to be recorded, maintaining the strength of both throughout, at the same time creating a variety of textures.

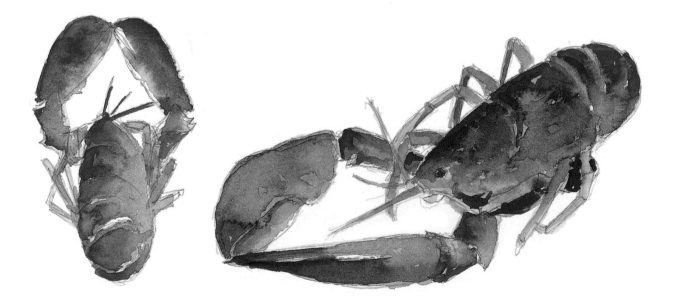

Lobster Studies

Lobster Step-by-Step

1 The first stage was to cover a preliminary sketch with an appropriate undercoat: in this instance, a mix of cadmium red and cadmium orange, a combination which proved to be bright enough for the job! This was painted onto dry paper using a medium-sized brush.

2 When this had dried, the main shadows on the body were established by using the now familiar system of intensifying the tone by using less water in the colour mixture. This was achieved by applying the paint along the length of the shell using a medium brush and a lot of very wet washes.

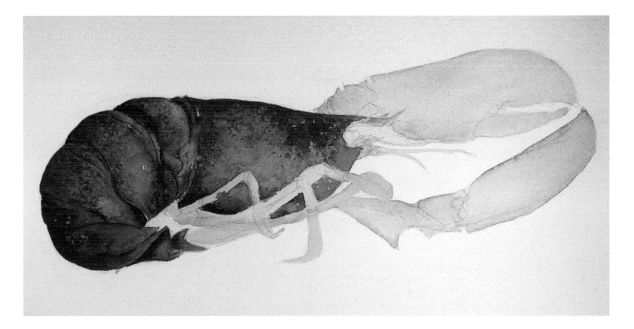

3 The next stage was to develop the speckled patterns around the top and back of the lobster. To achieve this I added some crimson lake to the cadmium red and orange mixture which gave it just the right amount of luminosity. Using a medium brush, I ran the paint along the top edges of the lobster's back. I then added a little clear water and pulled this downwards, diffusing the tone,

but not evenly. I used more of a dabbing technique to break up the smoothness, introducing the mottled effect. When this had dried, I reached for my small detail brush and applied a few dots to the deeper red at the edge of this section. I was careful not to over-do the specks and to ensure that they faded out softly.

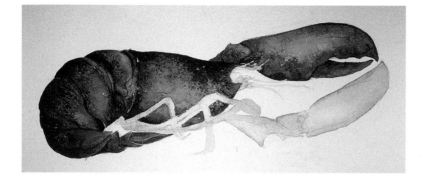

4 The pincers were a slightly lighter tone than the body of the lobster, and were treated in exactly the same way, only this time a small brush was used and a little more yellow was added to lighten the tone.

The mottled appearance of the shell was created by dabbing with a textured piece of kitchen roll and then adding a few dots of colour with a small brush

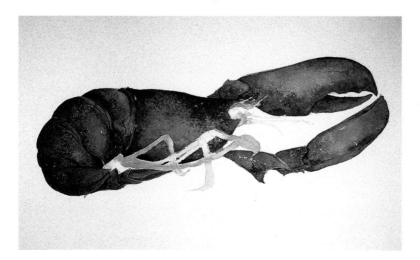

5 Finally the legs of the lobster were painted a lighter tone, allowing them to stand out against the dark shadows of the underside. This is known as a push-pull effect. The darker tones appear to push the lighter objects out in front of them, adding to the three-dimensional effect of any object sketched or painted in this manner.

Much water was used in creating the tone and texture of the pincers. A drop of water applied to damp paper will diffuse the previous wash of paint, lightening the tone and creating some textures as the paint dries into the fibres of the paper

Dark edges along the pincers were created by applying a strong mixture of ultramarine and burnt umber with a small brush

The feelers were almost drawn on using the wet tip of a small brush (No.1) and a steady hand

The darker section of the shell was painted with a dark mixture of cadmium orange, cadmium red and a little crimson lake to enhance the intensity of tone

Shaded sections required the addition of a little burnt umber which was painted onto dry paper using a small brush

A small brush and a little water was used to paint the legs, allowing the lighter tones to stand out against the dark underside of the shell

Lobster

POINSETTIAS

Unlike the previously featured flowers, the colours of this poinsettia are not natural allies. They are, in fact, visually opposed to each other. Red and green are what artists call complementary colours – these are colours which, when placed side by side, appear to vibrate along their edges, creating an optical illusion of movement.

Dark reds are created by mixing cadmium red with crimson lake and painting onto dry paper with a small brush (No.1)

The lighter leaves are created by painting darker tones behind them. An underwash is all that is required to provide the colour of some of the small leaves

The deepest reds are created by the addition of ultramarine to the cadmium red and crimson lake mixture

Sketchbook Studies of Poinsettia Leaves

When confronted with a group of objects that are complex in either shape or colour, it is always a good idea to isolate one or two key components (leaves and petals in this case) and to observe and record the colours and shapes carefully to aid your understanding of your subject. You will find that patterns will occur – not necessarily geometrical, but a set number of petals may appear to be evident and they may take on a regular pattern. Equally, the regularity of the leaves may be notable. Alternatively, an irregular pattern may be part of your subject's structure.

The green leaves were recorded with a particularly intense mixture of sap green and ultramarine. The blue was used to give a deep, warm glow to the darkest sections of the leaves, and was also used to create the shadows on the red petals. Using the same colour for shadows in the whole subject helps to maintain continuity of tone. This is quite an important point to consider. Shadows are not just the absence of light – they are the result of light and therefore carry colour. It may go against all your natural inclinations to mix a shadow colour to paint onto a red petal using chiefly blue and green. But be bold. The contrast between the deep red of the petals and the strong dark green of the leaves was challenging. Achieving the right balance of red and crimson for the flowers and green and blue for the leaves became a priority, and required a little artistic courage.

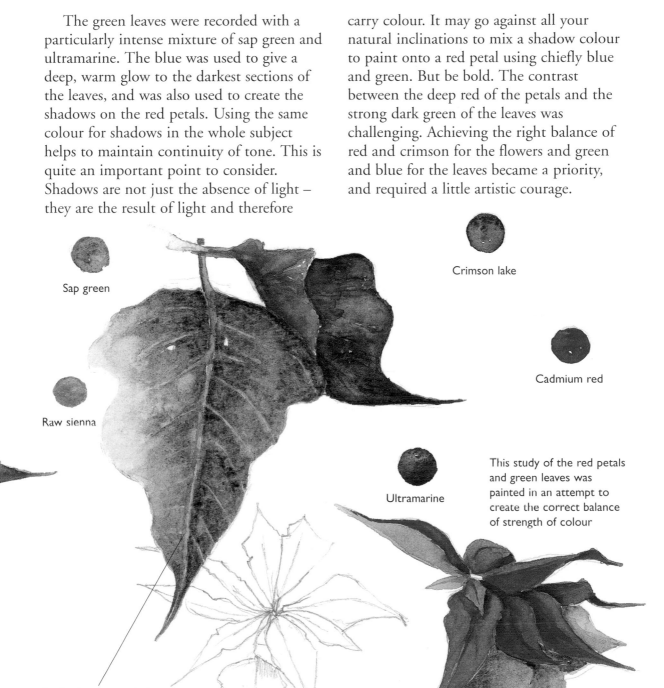

Sap green

Crimson lake

Raw sienna

Cadmium red

Ultramarine

This study of the red petals and green leaves was painted in an attempt to create the correct balance of strength of colour

Leaf veins are created by allowing the underwash to show through after the second coat has been painted

A study of the fabric in its flat state will aid understanding of the pattern. This will allow you to follow the pattern through the creases and folds

The folds and creases in this fabric study were created by applying a watery wash of ultramarine along the line of the fold and pulling the paint outwards, away from the darkest shaded area

Background Fabric Studies

Slight shading can be created by dropping a very weak, watery mixture of ultramarine and then allowing this to bleed into the existing colours

BACKGROUND

Background cloth can enhance a composition, but it does need to be chosen wisely and should match the strength of the subject. I chose this fabric essentially for the colour; the dominant red was a good match for the vibrant colours of the poinsettia flowers, and the folds and creases created a network of interest for painting. This network, however, did prove to be rather complicated and required studies to be made of the fabric pattern so that I could work out exactly where the stripes would be likely to go once they disappeared into a deep fold or crease.

Poinsettia and Fabric Step-by-Step

1 Having carefully sketched the outlines of the main shapes, I began this composition by painting all the red sections in one go. This first coat would serve as the highlights as the picture developed (the smallest, lightest petals being represented by the first undercoat of red paint applied). The next stage was to block in the rest of the picture with undercoats of the appropriate colours. You will already know which combinations to mix having made colour studies earlier (see page 57) and will be in an advantageous position when working on a complex composition.

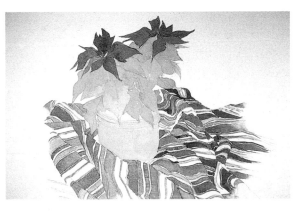

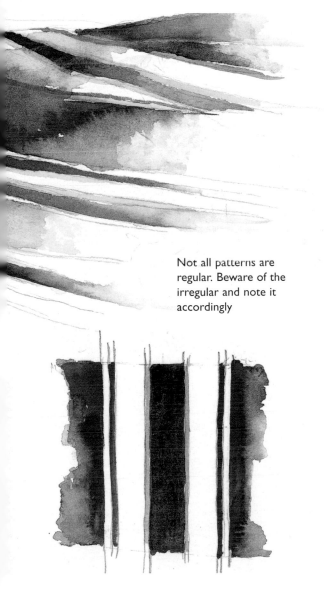

Not all patterns are regular. Beware of the irregular and note it accordingly

2 The shapes created by the folded fabric were reproduced by carefully following the line of the stripes with a small brush. This is why it was particularly important to make studies of the patterns of the fabric, allowing you to follow the lines of the stripes as the composition develops. The more familiar you are with your subject, the more confident you will be when working with it. One final word on painting stripes or similar details on fabric – always mix enough paint. Should you run out halfway through a stripe, the chances are that you will not achieve the exact same mix to complete the section. Always mix more paint than you think you will need, just to be safe.

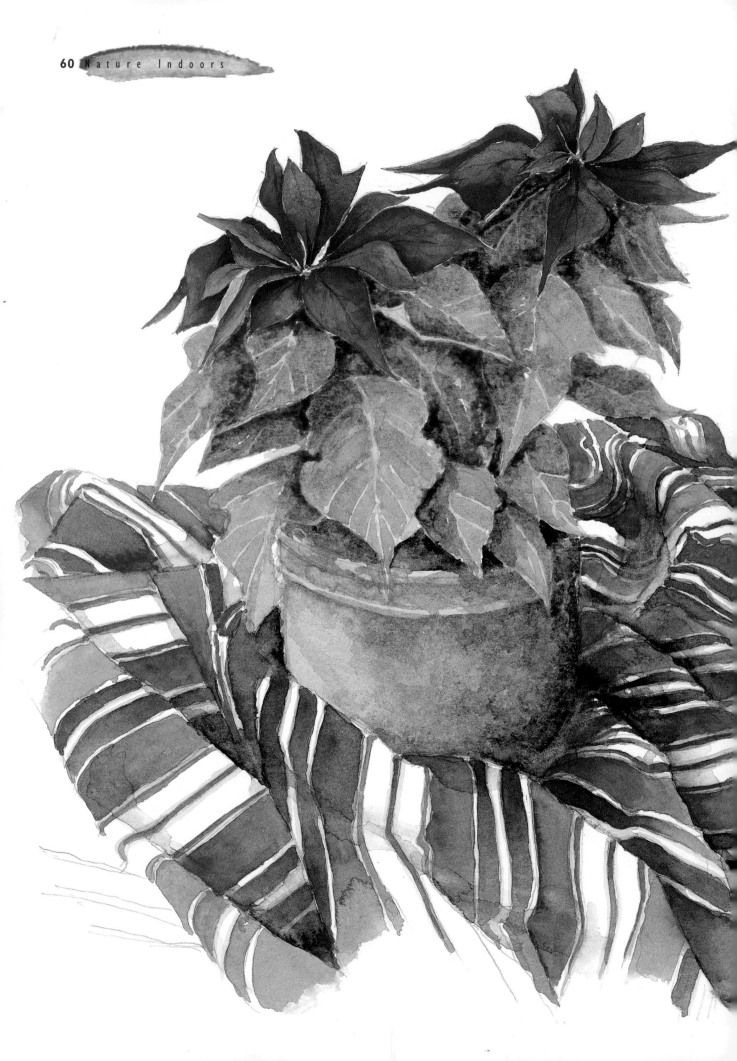

3 Having blocked in a watercolour base on which to work in the previous stage, the shadows on the flowers and leaves could now be painted. The very deepest colours in the painting were crimson lake, cadmium red and ultramarine for the flowers, and sap green and ultramarine for the leaves. These were used towards the centre of the composition where the shadows were strongest to give it a sense of depth. I used the push-pull effect again, which makes the lighter leaves appear to be in front of the darker sections – this optical illusion was discussed alongside the preliminary sketches of the lobster featured on page 52.

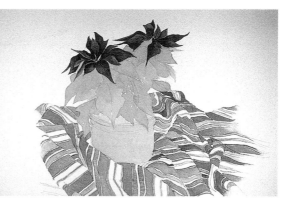

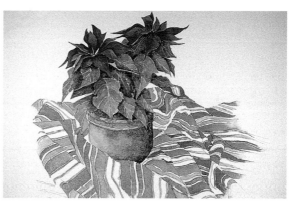

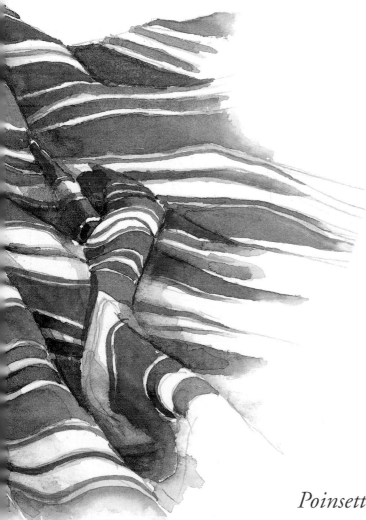

4 Finally, the folds in the fabric were exaggerated by applying ultramarine to create graduated shadows. The exact technique involved running a line of ultramarine paint along the appropriate lines of the folds, working onto dry paper. Before the paint had time to dry, it was pulled outwards along the direction of the fabric fold using a wet, medium-sized brush and clear water. This technique allows some paint to dry in the crease of the fabric making the darkest tone while creating a graduated shadow on other areas of the fabric. In the meantime it also maintains the wet, translucent look necessary for all good watercolour paintings.

Poinsettia and Fabric

PRIMULA IN WHITE POT

I chose this pot of primulas for the abundance of colour that it offered. Complementary purples and yellows sit easily beside warm greens. The white pot also acts as a good vehicle for painting shadows.

The impression of folds and twists in petals and leaves is created by adding a dark, intense tone of the appropriate colour

Purple and yellow (like red and green, and blue and orange) are complementary colours. This combination creates the strongest of contrasts and maximum impact

A granulated effect was created by allowing paint to run freely over rough paper

The white pot is shown in negative. This is achieved by the use of pure colour in the background, and the application of warm blues and purples, without attempting to record shape or form

MOVING OUT OF DOORS

Having mastered the basic skills and techniques of watercolour painting and put them to good practice within the safety and constancy of your studio or kitchen, all painters must eventually take the first steps outside to where a wealth of inspiring subjects lie in wait for the keen-eyed watercolour painter.

The first artistic move outside of the safe confines of your home can be intimidating and, frequently, off-putting. So many aspects of outdoor painting are different. The very atmosphere out of doors is more challenging. The light, for example, is rarely constant. Indoors, most people take advantage of the constancy of artificial lighting and the convenience of daylight bulbs. But outside, even with a clear sky, the position of the sun will change over a matter of hours with several results. Firstly, the position of shadows will change and, secondly, you could end up with the sun beating down onto your head, or back of your neck, making your painting position particularly uncomfortable. Then, of course, clouds can create frequent changes in lighting. This is all supposing, however, that there is a good amount of sunlight on the day that you have chosen to go out and paint, and that you are not faced with a cold, grey, wet day and a flat-looking landscape.

The other effect that direct natural sunlight has is on the way that your paints will dry. On a good, bright day with plenty of sun and plenty of shadows, the drying rate of watercolour paints both in your palette and, in particular, on your paper, will be greatly accelerated. This will require you to develop a more decisive style of painting as you will no longer have the luxury of five or ten minutes in which to move your paint around. Indeed, the water will not last long at all.

It is for these reasons that most of the subjects that I have chosen for this section of the book are studies or sketches and paintings of a small section of a larger scene. The Mediterranean window with its terracotta window box on page 75, for example, was a picture that could have been painted from a hotel window or a small, shady corner in a short period, and personal exposure to the full glare of the sun for hours on end was not a problem.

In fact, painting outdoor scenes from inside is quite a good starting point. You will have to deal with any atmospheric changes surrounding your subject, but you will be working in a controlled, comfortable environment sheltered from the weather.

It is for this very reason that I have started this chapter with a conservatory scene which made full use of natural light to create a web of shadows and shading across the walls and floor, but allowed me to maintain a level of working stability with my watercolour paints and paper.

When you do finally move out of doors to work it is best to travel light, taking only a small tin of paints and a hardbacked sketchpad.

So, to summarise here, acclimatisation is important. Start from a position of comfort and environmental stability, and gradually, as your confidence grows, take those few bold steps right outside the safety of your home, hotel room, holiday cottage or whatever. To begin with, choose subjects that will not require hours to record: small facets of buildings, a small clump of flowers in a garden, or even a few garden ornaments. These will be quite enough to allow you to gain confidence and always provide good reference material. But, finally, simplicity and portability of equipment is vital. If you are burdened with bags full of paints and different papers, a morning's sketching can turn into a major expedition, and this can spoil the spontaneity that watercolour painting allows.

CONSERVATORY

onservatories are usually warm places.
The amount of glass used in their construction
means that plants can thrive and that you are
guaranteed a good strong natural light. In view of
these qualities, they make an ideal starting point
when you feel that you are ready to leave the safety
of your kitchen studio and take that first step
towards working out of doors.

Before beginning any
composition, be it indoors or out
of doors, I always take my
sketchpad and make studies of
specific objects. In this case it was
the bamboo sticks for their
colours and the exotic fan leaves
with their twisting and curled
shapes. Curiously, both the
bamboo canes and the large fan
leaves contained a series of veins
or shapes that were best
represented by the use of lines.
The key difference was that the
lines on the bamboo canes were
positively painted onto the
underwash using a small brush,
whereas the veins on the leaves
were created in negative, again by
painting onto the undercoat, but
this time allowing only a little of
the underneath colour to show
through to represent a few of the
actual veins. While these objects
may not have been the central
features of the composition, the
colours contribute to the whole.
This is a fundamental principle
that applies to all types of
watercolour painting.

Once you have established the
colours of many of the key
objects, you will know where to

Lines on the bamboo
stalks painted using a
small brush (No.1)

Raw sienna is a good
warm colour to use
as an underwash

Burnt sienna was used to
create the shadows and
ridges, maintaining the
warm feel to this study

Studies do not need to be complete records of your subject. Fading out towards the corner or edge of a page can be visually effective

Leaving the edge of the leaf a very pale tone helps to enhance the twist here

Diluted sap green was used for the underwash

Veins created by painting a stronger sap green on top of the thin undercoat using a No.1 brush

Raw sienna dropped onto a damp underwash and allowed to bleed

Depth of tone created by adding ultramarine to sap green

Colours in stem created by using raw sienna and burnt sienna

start with your colour mixing as you sit in front of a scene with a blank sheet of paper staring back at you – just look to your sketchpad! As an underlying warmth of colour was required here, raw sienna and sap green were selected as the key colours with which to develop the underwash.

The chief difference between working in a conservatory with its many windows on the world, and working in a studio, is that the colour taken from the studies had to be combined with the colours created on the walls and floor by the light. The objects, from now on, only formed a small part of the plan. Daylight became a major factor for consideration.

Studies of Conservatory Plants

Conservatory Step-by-Step

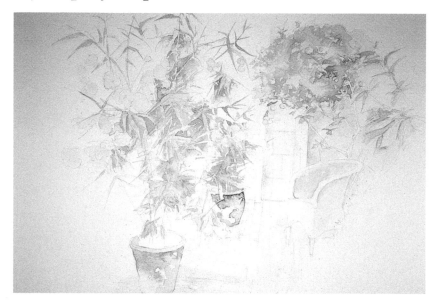

1 As with all watercolour paintings, the very first step, having established a pencil outline, was to block-in the main features of the composition. This was done by mixing the appropriate colours: sap green for the plants, burnt sienna for the pots, and a very thin mixture of ultramarine with a touch of permanent mauve for the shadows cast onto the walls and floor. I chose these colours for their lightness and warmth – qualities that are brought into prominence when the mixture is highly diluted. This was all done on dry paper using a medium brush.

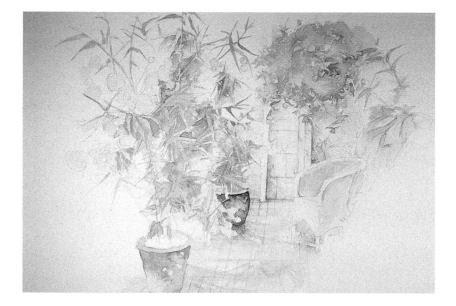

2 Before the first wash had time to dry, I mixed a slightly stronger version of the shadow colours (by using a little less water this time) and dropped this onto the floor area to strengthen visually the base on which all of the objects stood. This gave a little solidity to the whole scene as the paint bled onto the damp paper.

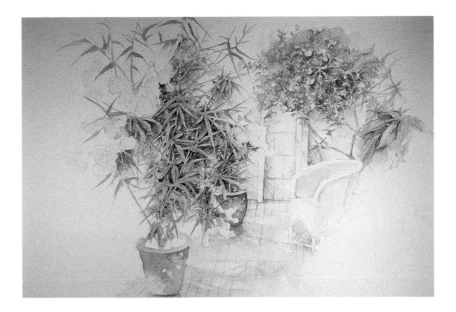

3 Having established an underwash, the next stage was to use this to represent highlights in the plants by painting the darker sections and shaded areas behind the light areas, making them appear to stand out by visually pushing them forward. (This is the same technique used in the earlier painting of the lobster – see page 54.)

This was achieved by adding ultramarine to the sap green undercoat and, using a small brush, carefully painting behind some of the more prominent leaves and features.

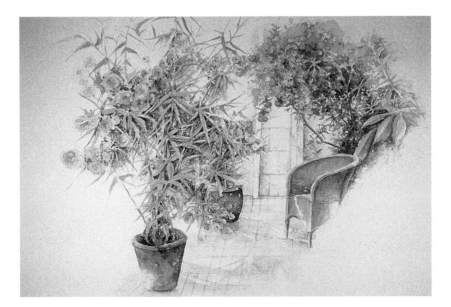

4 The penultimate stage in this painting was to establish the colours of the flowers, pots and chair. To prevent the picture looking fragmented and static, these sections were added using a great deal of water, allowing them to bleed and blend in with the colours of the floor and the leaves, using a medium brush.

Conservatory

5 The final stage to complete this picture was to fill the scene with daylight. As light is not a tangible object it is best depicted, or suggested, by shadows, as one cannot exist without the other – the strength of the shadow is totally dependent upon the light. So, by using subtle shadows a softness of light is suggested, whereas strong deep shadows will suggest an intensity of light.

To create a sense of soft lighting, I mixed another very watery mixture of ultramarine and permanent mauve to act as a second coat of shading onto the floor – only this time it would be painted onto dry paper, allowing much more definition of shape to be established. This was started with a medium brush, but completed (where thin lines were required) with a small brush. At this point, the converging lines of the floor tiles and the horizontal lines on the back wall became particularly useful as a grid upon which to work. The interplay of light and shade is so frequently enhanced by emphasising objects such as paving stones on a sidewalk, wooden planks on a pier or, as in this case, the tiles on a floor. This can be achieved just by reinforcing a few pencil lines – alternatively, adding a few lines painted with the appropriate colour using a small brush can prove to be an equally effective method.

These finishing touches completed this composition with its warm, soft lighting and shadows and its lush greenery.

Shadows were painted with a mixture of ultramarine and permanent mauve with a little rose madder dropped in to pick up the colour of the flowers, maintaining a unity of colour and tone in the composition

The lattice-work of colour was created by painting the shapes of the shadows on top of the lines of the floor tiles

TERRACOTTA POTS

Exposure to the elements gives a unique texture to terracotta pots. They take on a patina reminiscent of old rust combined with the sun-baked bleached out textures of the Mediterranean.

The key to recording terracotta pots is firstly in the drawing. Few of the natural objects considered in this book are totally symmetrical, but here is an exception. Pots are, by their very nature, symmetrical, and terracotta pots exposed to the weather eventually take on a near organic form which is best recorded by a combination of line drawing and paint dripping. As far as drawing is concerned, it is best to spend a little time on facets such as handles and lips as these areas will require special attention when you come to paint them. If you have clearly defined the particular shapes with a few pencil lines you will know exactly where not to paint, for instance, to create the suggestion of light catching the lip of the pot or, exactly where the shadows will fall on the handles.

Having drawn the pots, the textures were created by applying a wet wash of raw sienna to damp paper (the wet-into-wet technique examined in detail on pages 32–33). This started to dry to an uneven finish but before it had time to dry, however, a very watery wash of burnt sienna was dropped onto the pot shape and allowed to bleed freely, then blotted with a piece of scrunched-up kitchen roll. Once again, before this had dried, a little burnt umber was dropped selectively onto the shaded side and encouraged to bleed, creating a graduated shadow around the pot. This is the best method of creating textures using watercolour paint – a succession of wet washes onto damp paper, often dropping paint onto the paper, forcing the colours to separate and to dry to an uneven tone. Your choice of paper is quite important here – a rough paper (see pages 14–15) will afford a much more textured finish and will be able to stand up to a rapid succession of watery washes.

The inside of pots will nearly always appear to be darker than the outside. At the underwash stage apply the strongest wash to the inside area, and pull the wash outwards, diffusing it with water to dilute the tone

An underwash of raw sienna gives a warm base on which to create textures

Terracotta Pots

The lip of the pot was left unpainted to create highlight, emphasising the curve

Shadows on pots or circular objects are graduated by pulling the paint around the shape in a single wash from dark to light. The tone changes gradually as the paint on the brush runs out

Burnt sienna

The darker side of the pot was painted with burnt umber onto a damp underwash and allowed to bleed

Burnt umber

Raw sienna

Texture on pots was created by dropping clear water onto the damp underwash of raw sienna and burnt sienna

The lip of the pot is emphasised by dark shadow, painted with a No I brush

Lips and rims, and even darker tones, still can be created by the addition of a little ultramarine. This can be achieved by painting underneath the rim (made considerably easier if a good set of pencil lines are available to work around) using a small brush after the paint has dried, and pulling the paint downwards by dripping water onto it. This should be used sparingly if the terracotta colour – glowing with the warmth of the midday sun – is to be maintained.

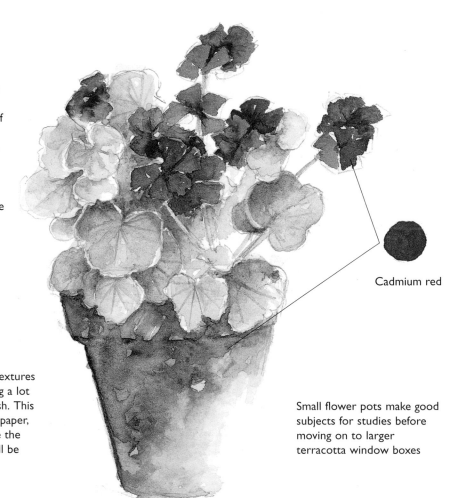

Geraniums and terracotta pots make good partners as they are both warm natural objects. The cadmium red of the flowers can be dropped onto the burnt sienna while damp to maintain the unity of colour, preventing the flowers and pot from looking as though they were painted separately

Cadmium red

Weatherbeaten terracotta textures are best created by dropping a lot of water onto the underwash. This requires a strong (ie heavy) paper, and the rougher the texture the more effective the result will be

Small flower pots make good subjects for studies before moving on to larger terracotta window boxes

Study of Geranium in Terracotta Flower Pot

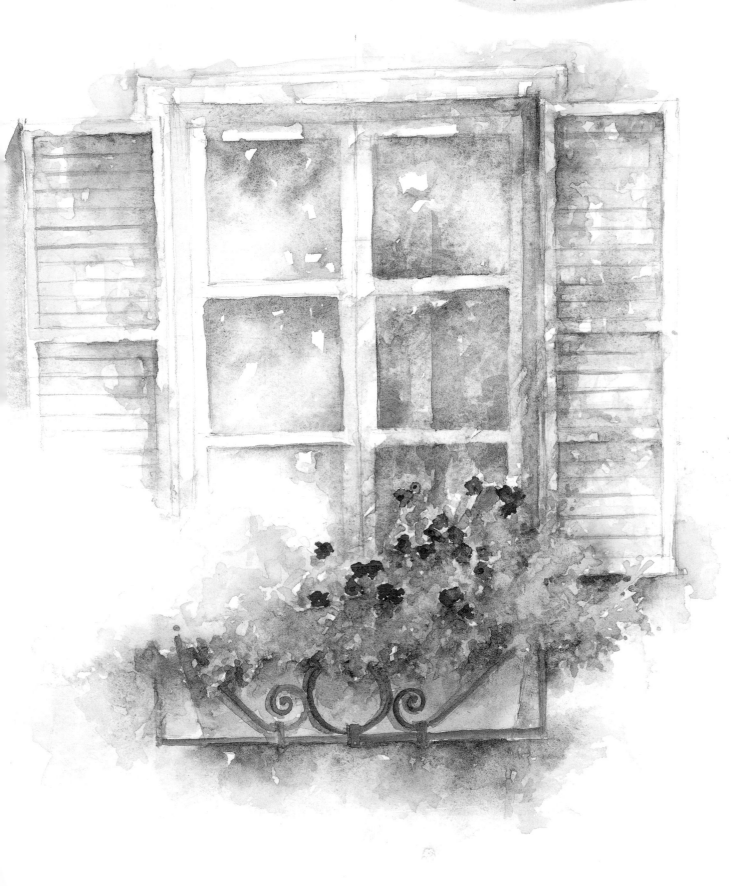

Terracotta Window Box

STONE

Crumbling brickwork, lichen-coated stone and cracked stucco are marvellous subjects for the watercolour artist – in fact the medium could have been developed for these subjects alone – and they are to be found in towns and cities around the world.

Stone and brickwork are part of our everyday lives. Most built environments in every town, city, village or development across the globe, contain vast amounts of this natural material. While brick and stone themselves are inorganic, mosses, lichens and moulds grow on them to create a wonderful array of textures, tones and shapes, and are a constant source of delight to the artist who has learned to look for subjects in the less conventional places. These can be painted by using a minimal number of colours and by exploiting the qualities of water and textured watercolour paper to their fullest capacity.

The method that I use to recreate these natural textures is basically the same as with all subjects – start with a big, free wash, and gradually add more colour, refining the subject in the last stages with a small brush. The technique for this weather-stained gateway

is the same as that described for painting terracotta pots on pages 72–74, only in this instance more colours need to be employed to record the fungal growths that can occur on crumbling stone and brick.

Raw sienna

Ultramarine

Burnt umber

Burnt sienna

The architectural symmetry of stone structures and the natural disorder of decay combine to produce some splendid subjects for the watercolour artist. An added bonus is that they occur in both urban and rural settings

Stone Pillar

Stone Gateway Step-by-Step

1 Using rough textured paper, I established the background against which the textures and tones would be seen by wetting the areas of paper behind the actual gatehouse. As this began to dry, a little ultramarine was dropped onto the sky area and a mixture of sap green and ultramarine was used to create the bushes and trees. Working onto wet paper prevents hard lines and watermarks developing. This softness is important in a backdrop as it does not distract the viewer's eye from the foreground detail.

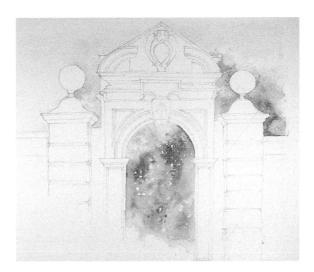

2 Having established the background, the next stage was to put a warm wet-into-damp wash onto the stone and brickwork. A wash of raw sienna was applied to all areas of brickwork with a medium size brush to create a fairly even under-surface upon which to use more colour to suggest bricks later. The same brush was used (the tip only – not washing with the whole length) to drop some raw sienna onto the areas of white stucco to represent the stains found on well-weathered plaster. This was then applied to dry paper to enable some control over its shapes, but also to create a few shapes with some clear distinctions. Where any softening of outlines was required, the

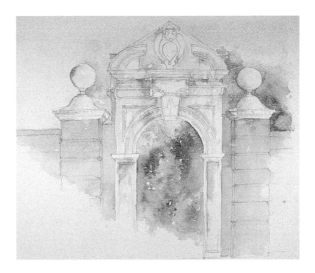

outer edges of the paint were blotted lightly with a piece of kitchen paper.

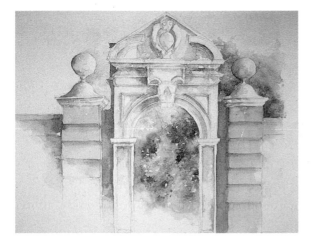

3 Having completed the full underwash it was time to establish an element of form by painting in the main areas of shadow. This was done with a small brush and a mixture of raw sienna and burnt sienna, working onto dry paper to avoid runs or bleeds – the shadows needed to be fairly solid to allow the raised stone and brickwork to stand out. This stage was not painted with architectural accuracy, although a little more attention did need to be given to the positioning of certain shadows.

Stone Gateway

4 The final stage of this painting was to establish the texture of both the brick- and stonework. While the appearance of both are very different, the same technique was used to create the weathered textures (that is, the same technique as was used on page 73 for the final stage of painting terracotta pots).

This technique involves dropping some very watery and usually dark paint onto dry paper in the areas where you wish the textures to occur. When the water begins to evaporate and the paint starts to soak into the paper, drop a few droplets of plain water from a medium brush on top of these patches. The result will be that the paint is forced outwards by the water and dries (as it was applied to dry paper) to an uneven texture with a line or watermark around the patch. This is a particularly effective technique to use when you wish to portray the textures of rock, brick, stone or other similar material.

Lastly, the shadows were strengthened by the addition of a mixture of burnt umber and ultramarine. This was, as with most final details, painted onto dry paper using a small brush in areas which represented the undersides of ledges and carvings. This both reinforces their visual strength and helps to push the lightness of the raised part out towards the viewer, adding to the illusion of three dimensions on a flat sheet of paper.

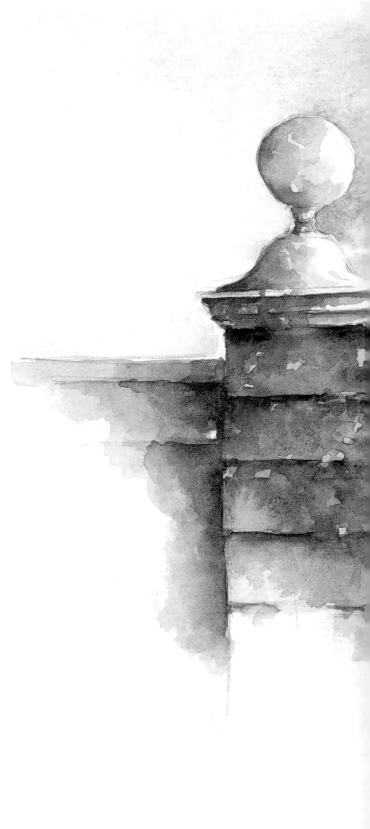

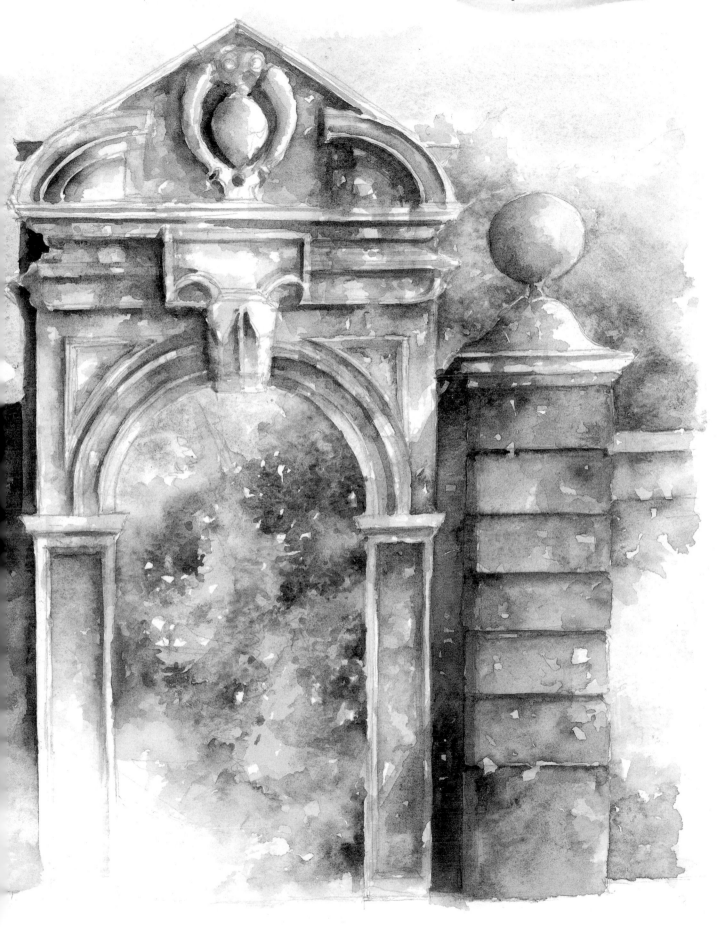

Study From an Artist's Garden

Sketchbook Study of Stone Head

Stone can take on many appearances, from the warmth of sandstone to the harsh coldness of flint. Both are a challenge to the watercolour artist seeking soft colours and varied textures to record

The amount of water used in recreating textures requires you to use at least a medium-size brush

Textures created by the action of lots of water with little paint on rough textured watercolour paper

RED HOT

Colour temperature is important to the painter. It is not a tangible thing, but an impression, using colours to impart the idea that the viewer is looking at an object which is hot to the touch, or suggestive of the ambient temperature of the day on which the painting was made.

The chief colours needed to create the suggestion of warm or hot colour temperature are reds, yellows and oranges (although many purples tend to be classified as reds by paint manufacturers, while others are classified as blues, see pages 12–13). Yellows – especially cadmium yellow – are frequently used as underwashes to bring out the most vibrant qualities of the reds (although there is a range of lemon yellows that will do little to impart any feeling of warmth). Oranges are considerably more straightforward and dependable – cadmium orange, for example, is frequently used to add strength and additional warmth to reds. It is a useful colour to bridge the gap between yellow and red, especially when it comes to graduated shading on curved objects. The touch of cadmium orange dropped onto the poppy opposite has added a little visual weight to the petal and created that middle tone between the extremes of light and dark.

Getting to know the qualities of water-colour paints is important because the colours have considerably different qualities in terms of strength and the way they react when drying. Cadmium red, for example, is an invaluable colour for finishing off, but it is of little value by itself. It looks good when wet, but soon dries to a pale, disappointing tone if applied directly to white paper. Cadmium red was the key colour to the poppy study, but was painted on top of a cadmium yellow underwash. This is by far the best way to employ this particular red.

Crimson lake is the colour I use most to create deeper tones of red without losing any of the vibrancy or translucency of the colour. It is a deep warm red which, like most reds, has little use in isolation but becomes almost indispensable when mixing colours which glow with the heat of the midday sun.

Reds, oranges and yellows are often most effective when they are at their strongest – the more intense the colour, the more noticeable it becomes. This is where tube paints can be of particular value. As I mentioned in the introductory pages, tube paints are particularly useful for adding body to a picture and form a valuable part of my studio equipment, but they tend to stay in my studio for practical reasons. A squeeze of crimson lake into your palette lid will give you a quantity of strong, thick paint which, when mixed with any other colour, will provide a much more intense tone owing to the pure volume of paint added. Even better

– a touch of undiluted tube paint applied to a still-damp colour wash will create a stunning bleed with the deepest, darkest tone at the point of application. This was the technique used to create the inner tones of the poppy study featured below.

Study of Wet Poppy

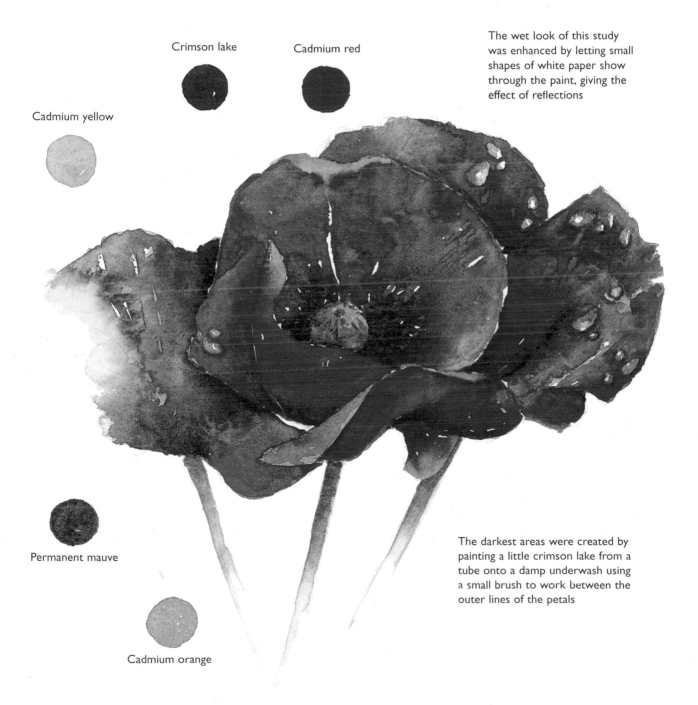

Crimson lake

Cadmium red

Cadmium yellow

The wet look of this study was enhanced by letting small shapes of white paper show through the paint, giving the effect of reflections

Permanent mauve

Cadmium orange

The darkest areas were created by painting a little crimson lake from a tube onto a damp underwash using a small brush to work between the outer lines of the petals

Reds, oranges and yellows are to be found in great profusion in both wild and cultivated gardens globally. They are some of the most frequently occurring natural colours.

Yellows mimic cadmium red in that they may look bright, vibrant and deeply coloured in your palette lid, but on paper they often dry to a barely visible tone. You can, however, use this to your advantage by creating an undercoat which can be used for the twists and turns of petals, especially as they are caught by the light.

Studies from a Wild Garden

The twists and folds that occur so naturally in flower petals are recreated by careful observation, accurate drawing and allowing light areas to stand out against shadows

Cadmium orange

The darkest parts of flowers will usually be inside or at the base

Cadmium yellow

The idea of form is created by the interplay of light and shade. The darker petals appear to push the lighter petals forward, enhancing the three-dimensional effect

Darker tones will usually require the addition of orange rather than a stronger mixture of the same yellow, which will rarely help to build up a body of tone. A thin yellow will always look like a thin yellow, however many coats you apply.

I usually paint the undercoat of a yellow or orange flower study on dry paper since these colours tend to 'disappear' as they dry. They will dry to a light enough tone without the need for any more water! This also means that the underwash will dry more quickly. This process is normally undertaken with a medium size brush.

As soon as the underwash is dry (or at least nearly dry) I change to a small brush and apply cadmium orange to any yellow flowers, or maybe a little red, depending on the actual colour, and paint into the darkest sections, taking great care to leave the lightest parts of the petals untouched.

The natural disorder and chaos of a wild garden can create a wealth of shapes, lines and combinations of colour. Even a small corner, quickly sketched, can be very appealing

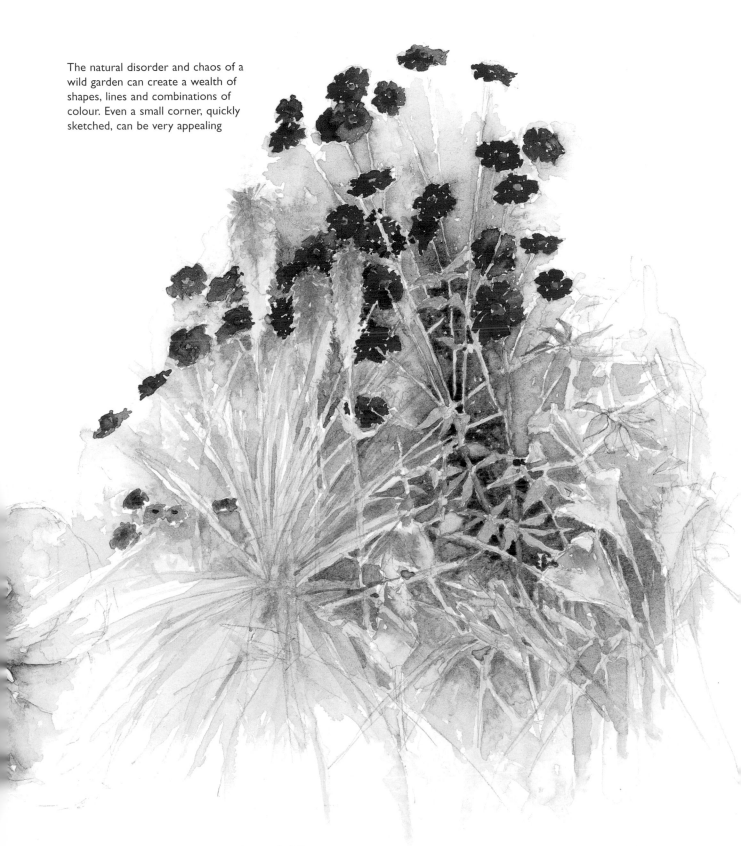

Sketchbook Page of Wildflowers

Wild Poppies

The deepest greens were
painted using a combination
of sap green and ultramarine

The reds of the poppies
were created by painting
cadmium red on top of a
cadmium orange underwash

This composition concentrated mostly on the
undersides of the poppies that had been
flattened by the rain

COOL BLUE

'*One night I went for a walk along the empty shore. The deep blue sky was flecked with clouds of a deeper blue than the fundamental blue of intense cobalt, and others of a clearer blue like the blueness of the Milky Way. In the blue depth the stars were sparkling . . . opals you might call them, emeralds, lapis lazuli, rubies, sapphires. The sea was very deep ultramarine – the shore a sort of violet and faint russet as I saw it and on the dunes some Prussian blue.'*

VINCENT VAN GOGH 1888

This quote by one of the world's best-known and best-loved painters shows a real understanding of the nature and qualities of blue paints.

Unlike the reds and yellows featured on the previous pages, blues and violets are quite predictable – they are more what you might call, 'what you see is what you get' paints, in that their appearance will change little from tube or pan to paper. This does make painting with them easy.

Few paintings will contain all warm or all cold colours and, inevitably, some mixing will take place. It is interesting to note that some of the violet colours can take on the colour temperature of any set of colours surrounding them, making them particularly useful. However, my key cold colours are cobalt blue, ultramarine violet and rose madder.

Cobalt blue is a mid-blue, but inclined a little more to the cold end of the colour scale. It is a fresh, light colour that is good for landscape work as well as detailed studies, but is, perhaps, at its best when it comes to painting skies.

Rose madder is a cool, subtle pink paint that has limited use and serves little purpose in a landscape painting. It is, however, very good for tinting where an element of pink or red is required, while maintaining the cool colour temperature (if you wish to avoid the introduction of crimsons or cadmium red).

Ultramarine violet is one of those chameleon-type paints which will take on the mantle of its surroundings. Ultramarine, or French ultramarine (to give it its full name) is a blue paint which is naturally inclined towards violet. Ultramarine violet is a colour in which the violet element has been enhanced. If seen against cool colours such as cobalt, it will take on a cool feel. Equally, when set against colours such as crimson lake, it can take on a warm feel. For this reason I find it a particularly interesting paint with which to work.

The study of sweetpea flowers opposite is a combination of many blues and violets, reminiscent of a snapshot of a cluster of flowers in a cool shady spot on a summer's day. So as not to become engrossed with botanical detail, I treated the subject to a very free interpretation, using much water and paint in quick succession, with a medium brush. When the underwash had dried I applied the darkest tones with a small brush, dropping a little water on the outer edge to encourage a little bleeding, again capturing the spirit rather than the detail of the subject.

The idea of capturing the spirit of a subject or scene is not necessarily an ethereal concept, or an excuse for lack of constructive painting – it is, quite simply, using the watercolour medium to its fullest, freest effect. The spirit was not so much in the shape as in the range of wet, cool tones that only blue and violet paints can create.

Sweetpea Study

The richness of colour in this study was achieved by a combination of the strength of tube paints and the subtle wash of pan paints

Ultramarine

Permanent mauve

Rose madder

Cobalt blue

Ultramarine violet

The coolness of this cluster of sweetpea flowers has been created by combining the qualities of an assortment of blues and violets

The paint that has been washed freely behind the flower heads serves as a background colour only and need not represent any particular shape or object

Hydrangea Garden

One colour, rose madder,
served as a base for both of
these studies

Rose madder

Cobalt blue

Cobalt blue was added to this
study to give a cool feel to
the flower and to create the
shadows

Permanent mauve

Permanent mauve was added
here to warm up the colour
of the flower

When painting a garden
scene it is important
not to become too
concerned with detail.
Backgrounds can be
created by colour
washes without
necessarily drawing in
details with a brush

Each individual petal will never be painted on a
large flowerhead such as these. It is important,
therefore, to practise the skill of suggestion.
This involves picking a few selected petals and
leaving them a lighter tone, while creating a
series of near abstract shapes behind them
through several applications of paint and water
(see study on page 89)

The deepest tones of the foliage were created by applying a mix of sap green with cobalt blue to dry paper. This always produces a darker tone as the paint is not diluted by water already on the paper

Studies are important to establish the shapes of petals in a cluster

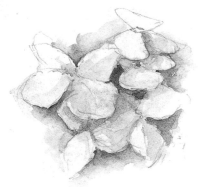

The same blue that was used for the flowerheads has been pulled down to mix with the earth colours, creating a unity of colour in both the light and shaded areas

Petals are created here through close observational drawing and free use of background colour, making them stand out

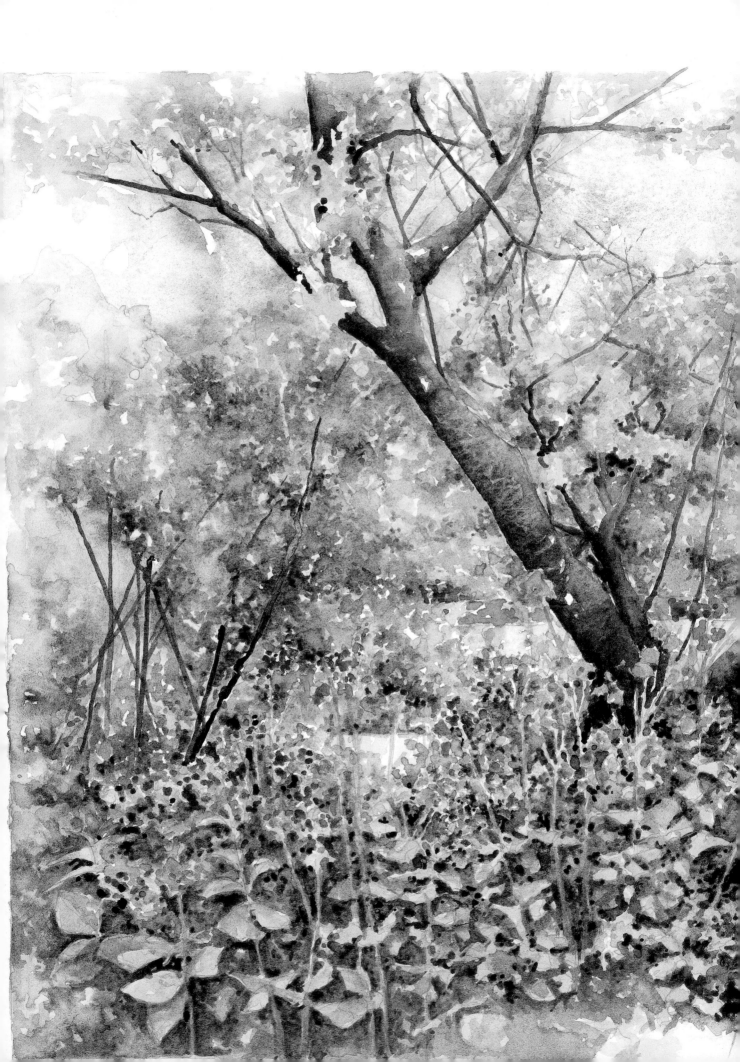

An Artist's Garden

NATURAL LANDSCAPES

Landscape painting is the goal of many artists and is, perhaps, the ultimate extension of all of the skills considered so far. It involves a wide variety of techniques, as well as a willingness to expose yourself to the unpredictability of the elements.

Working in the landscape requires several skills – not least a fresh way of seeing. We often approach landscapes with a preconceived idea of what we expect to see, rather than seeing what is actually there. Our notion of a rural farming landscape may well be conditioned by idealised or romanticised visions which, when we are confronted by the stark reality of towering pylons and visual clutter (reminding us that we live in the modern world), suffers a serious blow. It is, therefore, best to approach landscape painting with an open mind so as to avoid disappointment just in case the reality of the scenes we find do not always live up to our expectations.

Another skill required for landscape painters is understanding exactly what you see and how you are going to record this in paint. Much of the visual appeal of landscapes is in the open spaces and distances that we see. These open spaces are not tangible things that have colour and form so we, as artists, have to learn to use colours and tones on the furthest objects on which our eyes can focus in order to suggest space and distance. I have devoted several pages to the idea of working on blue tinted paper when outside in the landscape, as blue will usually be the dominant tone in distant lines of trees or skylines. Colour temperature also becomes a major consideration and the sensation of heat or cold in the landscape can be clearly defined by choice of colours based upon the knowledge and experience gained from your experimentations in Chapter 3.

Apart from the aesthetic considerations, there are a few practical points to consider before heading for the open air. Equipment warrants serious consideration and your choice will be greatly determined by your intentions. If, like me, you will more often than not be wanting to visit areas where you can make some visual notes and sketches in the peace and calm of the countryside, then your choice of equipment need not be complicated. The same basic kit that was described at the beginning of Chapter 3 will suffice, but you may wish to include a folding stool. This will allow you a little more comfort, as even sketching in the landscape will take more time than studies of gardens and pots – there is simply more to organise on your paper.

If, however, you wish (as we all do from time to time) to spend an entire day immersed in the pleasure of the countryside, and have gone with the intention of finishing a painting or two during your stay, then a couple of additional items may be of value. A small, portable easel can be particularly useful if you are going to be painting from one position for a long time as it allows you to stand up and walk away from your picture, and to return without moving the position of your paper. The disadvantage, however, is that you will also need a drawing board on which to secure your paper, to avoid it being caught by the wind, and this increases the weight of the equipment that you will need to carry – while easels made from modern metals are relatively light, drawing boards remain heavy.

A final thought here: landscapes need not be rural outposts miles away from human habitation. While the pleasure of a few hours spent in the peace and tranquillity of a sparsely inhabited spot is undeniably rewarding, you do not need to go to the far ends of the earth to discover landscape subjects – sometimes, they can be found in your local park.

WOODLANDS

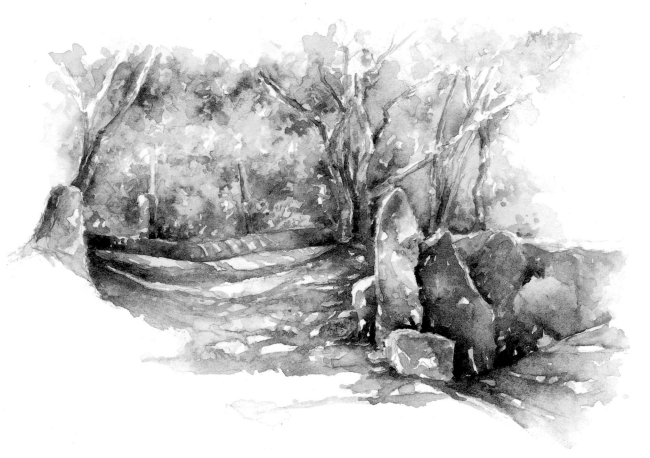

The woodland landscape is full of painting opportunities for the watercolourist – in particular it presents a huge variety of tones and textures to explore. Perhaps one of the most appealing aspects to look out for when painting woodlands is the unique interplay of light and shade to be found. The sunlight shining through the branches and foliage of the trees can create an intricate pattern of dappled shadows which will add even more interest to the abundant textures of the forest floor – always be sure to record this in your work.

Woodland Sketches

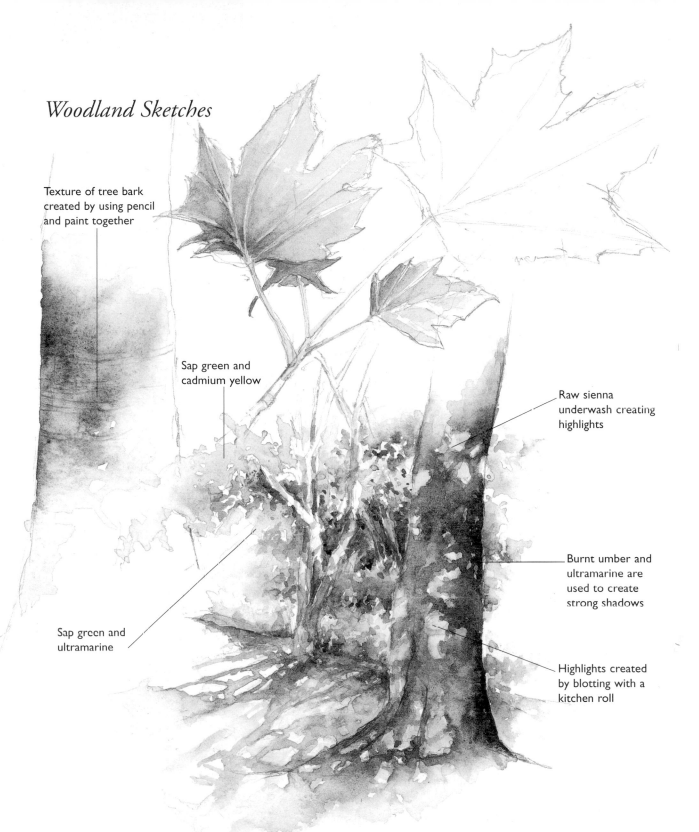

Texture of tree bark created by using pencil and paint together

Sap green and cadmium yellow

Sap green and ultramarine

Raw sienna underwash creating highlights

Burnt umber and ultramarine are used to create strong shadows

Highlights created by blotting with a kitchen roll

I like to make lots of sketches and studies before embarking on a major painting to gain as much information as possible about the subject and, in particular, about the colours of the day. This will include the colours of the leaves, the colours that make up the tree trunks, and the colours of the shadows that are cast by the trees onto the forest floor. It is worth noting that while a wealth of tones and colours exist in woodlands, they will generally be within a limited range. This means that you can mix most of the colours you need with only a few paints, namely the natural 'earth' colours – raw sienna and burnt sienna, burnt umber and sap green.

Studies of Tree Bark and Roots

Texture of stripped bark created using a B grade pencil overwashed with raw sienna and yellow ochre

Outer bark created with a thin wash of ultramarine

The natural patterns created by exposed, tangled roots are worth recording in a sketchbook. You only need two colours to do this – burnt umber and raw sienna – and it will prove to be an excellent exercise in painting tones

Recording the textures found in the woodland can be a rewarding experience for the artist. The bark on the tree trunks, fallen branches and exposed roots all offer an endless supply of patterns and textures to explore and paint.

To give the impression of the linear nature of many of these old, gnarled trunks and branches, draw the textured patterns of the bark with a B grade pencil. Then paint over these with particularly thin washes of paint so that the pencil lines can still be seen to full effect as shown opposite. While the examples shown are little more than mere tinted drawings, the pencil work is, without doubt, the most prominent feature of the studies. This makes such subjects particularly suited to outdoor sketching where just a small pad, a pencil and a small, pocket-size watercolour tin is all that you can carry.

'Warmth' of colour in the wood created by mixing raw sienna and burnt sienna

Look for the contrasts in colour and tone that broken bark and exposed wood can create

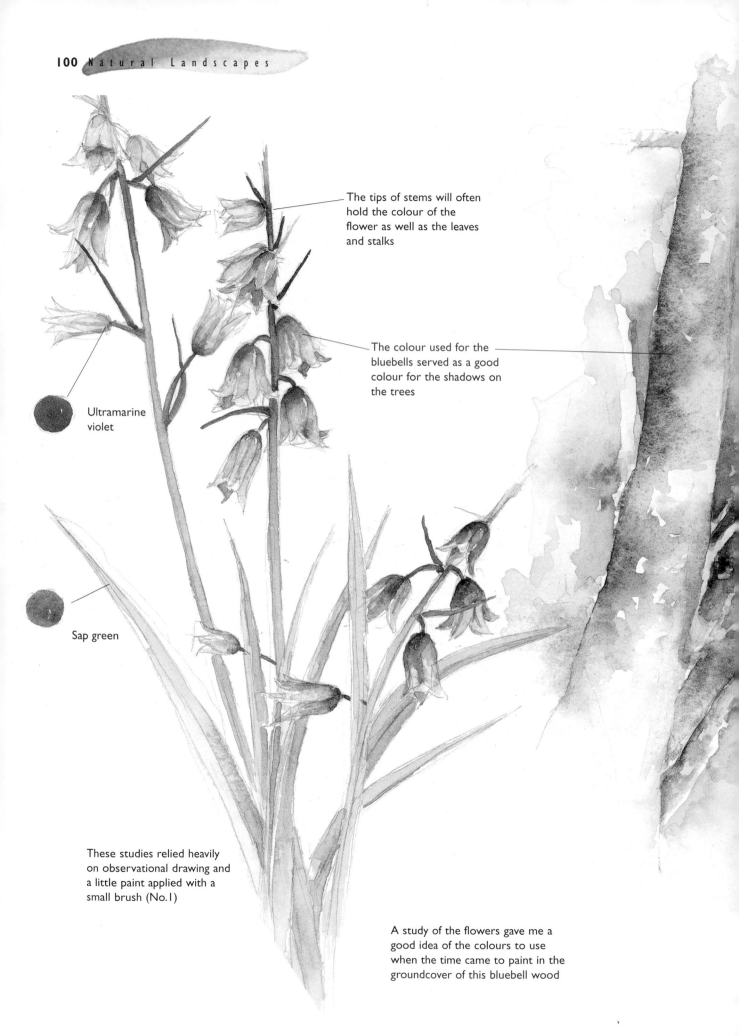

The tips of stems will often hold the colour of the flower as well as the leaves and stalks

Ultramarine violet

The colour used for the bluebells served as a good colour for the shadows on the trees

Sap green

These studies relied heavily on observational drawing and a little paint applied with a small brush (No.1)

A study of the flowers gave me a good idea of the colours to use when the time came to paint in the groundcover of this bluebell wood

Trees appear as both positive and
negative shapes when caught by the
early morning light

Sometimes a limited palette can produce
more cohesive results. This scene was
painted using only ultramarine violet, sap
green, raw sienna and burnt umber

Bluebell Woods

Woodland Scene Step-by-Step

The change of any season can produce some visually striking effects. This autumn woodland scene has a wealth of rich colours and subtle tones, recorded as the leaves began to fall, carpeting the ground with oranges, reds and golds.

1 The first stage of this picture was a free, fluid application of paint, embracing all of the colours in this rich, change-of-season scene. The paint was dropped freely onto previously dampened paper and allowed to bleed, resulting in a soft underwash of yellows, greens and oranges covering all areas except the main tree trunks and branches. These colours were applied with a large (No.14) brush using raw sienna, burnt sienna and sap green.

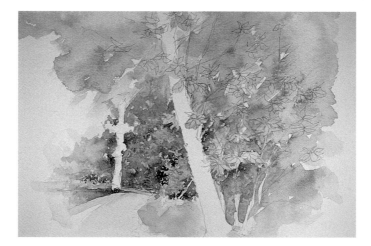

2 As the underwash was drying, I mixed the colours for the deepest, darkest sections in the far distance. This involved mixing ultramarine with sap green and a little burnt umber. The paint was then applied carefully to the shaded areas in the background using a small (No.1) brush to create a feeling of depth. The reason I chose a small brush for this application was that I needed to paint behind some of the middle-ground section – the bush on the immediate right-hand side of the path, for example. Painting behind objects in this manner makes them stand out even more.

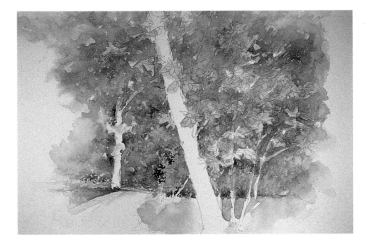

3 Having established the background, the picture had an anchor. By this, I mean that it was now possible to make some decisions about the depth of tone needed for the middle ground which held the bulk of the trees and foliage. The technique used for painting the main colours into this scene was essentially the same as that used in the first stage – except that this time the colours were stronger and deeper, being intended as a final layer, rather than an undercoat.

Using a medium brush (No.6) to enable a good flow of paint to be achieved, I started by dropping some sap green onto the appropriate areas. As this was drying I dropped raw sienna onto the foliage sections in rapid succession. I also found it helpful to enhance these with a few touches of cadmium orange and cadmium red to heighten the colours.

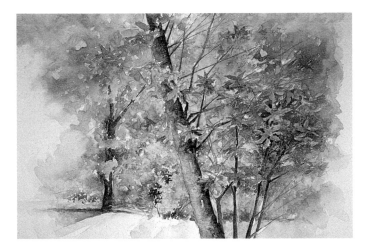

4 The next stage of this painting was to paint in the trees and branches. Careful attention to light and shade was required to do this. The light was falling on the left-hand side of the tree, allowing the other side of the tree to take full advantage of the natural shade colours of burnt umber and ultramarine.

The branches and twigs were, initially, treated to a wash of raw sienna and, as this was drying, strengthened by the addition of burnt sienna at key points. When this had dried completely, the previously mentioned shading mixture was applied to the darker edges of the trunk, branches and twigs with a small (No.1) brush and pulled around the shape of the branches using a little clean water.

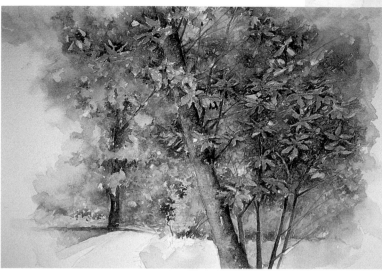

5 The penultimate stage of this painting
was to repeat the technique used in the
second stage – putting on the deepest,
darkest shadows of the woods and allowing a
few leaf shapes to stand out. This was chiefly
done with a small brush, allowing an
element of drawing with the paint brush
around a few selected shapes.

Finally, the ground was painted. As this
was made up of fallen leaves, colouring was
not a problem. The remaining colours in my
palette were then dropped onto the ground
area using a medium brush and allowed to
bleed freely.

The richness of colour and the fullness of
the foliage in the woodland scene required
that the full range of watercolour techniques
be employed to do the scene justice.

When the leaves in the park start to turn
from green to the warm rust tones that
denote an imminent change in the seasons, a
whole new technique becomes important –
that of dropping paint onto sections of
foliage where the change of colour occurs.

This is particularly effective as the colour
blends gently with the green surroundings.
This technique involves laying a strong
underwash of the appropriate green onto the
bulk of the foliage and then, while this is
still wet, dropping on a very watery mixture
of burnt sienna enhanced with a little
cadmium orange or red which will bleed
outwards, maintaining a core of strong
colour in the middle.

Woodland Scene

WATER

Stepping Stones

W*hen we look at a lake, pond or river, what we really see are the surrounding objects, reflected by the light of the day. The strength of the reflection will be determined by the strength of that light as it carries the colours of the immediate environment.*

What we really need to look at as we set up our painting kit by a stream or a lake is what is happening around us. Are the trees green, gold or rust, full of leaves or bare branches? Are the rocks or boulders cool granite or sunbleached yellow? Is the sky azure blue, full of pure white high clouds, or overcast and grey? Then, when we finally look at the water, we will see all of the surrounding things reflected in it, and it is these that will determine the choice of colours that we make as we come to paint.

Brush strokes pulled downwards on damp paper can enhance the effect of reflections

These short, sharp streaks of white suggest light bouncing off water. They were created by scratching the finished painting once dry with the tip of a very sharp object (the point of a pair of compasses or a needle; knives are rarely sharp enough at the tip), removing the surface of the paper and exposing the fibres beneath. Ensure that the work is completely dry before attempting this technique – damp paper will tear quite easily

Stone Bridge Step-by-Step

As with most paintings, the primary concern here was to block-in the main shapes without too much concern for detail.

1 Using a large brush, the main shapes of the bridge and the background foliage were painted in. A basic palette of ultramarine, burnt umber, raw sienna and sap green was used, and a lot of water was added to allow a free flow of colour and tone, creating an overall unity of colour. While the paint on the paper was still wet I made sure that the colours of the background trees were pulled downwards into the river to create the correct underwash to work onto.

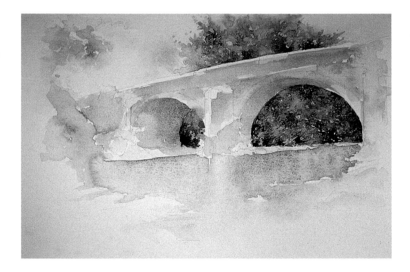

2 As soon as the first wash had dried it was important to establish the exact colours and tones of the trees immediately behind the bridge (the darkest sections at the bottom and lightest sections where the light caught the tops). This was achieved by three processes – firstly, applying a wash of sap green and raw sienna to the middle areas with a medium brush. As this was beginning to dry, the darker tones along the river bank were painted using the same brush and allowed to bleed upwards into the middle tones. The final stage involved dropping a little raw sienna onto the very top area of the trees to serve as highlights. This created the three levels of tone – light, middle and dark – that were necessary to make the trees come alive.

3 The same principles were applied to the bridge – using slightly different techniques and colours. The bridge had three very clear areas of tone: the highlights along the edges and ridges, the warm, middle tones of the stone, and the very well-defined shadows underneath the arches.

The technique used on the bridge is wet-into-wet, which I generally use for all stone-work – washing and blotting in quick succession to create a whole range of textures (see pages 32–33). The first coat here was of the same warm raw sienna that was applied to the tops of the trees, washed on using a medium brush with much water. As soon as the water started to be absorbed into the paper, an equally watery wash of burnt umber was dropped on to darken the stone colour. Then, in rapid succession, more

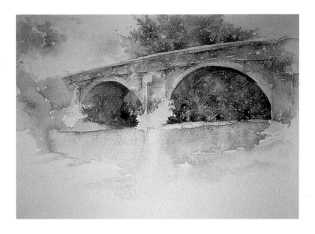

blues, browns and yellows were dropped on and allowed to bleed, only blotting with scrunched-up kitchen roll when necessary.

The shadows underneath the arches were painted when the paper had dried as a clearly defined edge was required, in keeping with the light of the day.

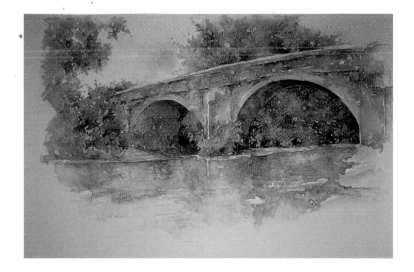

4 The last stage was to complete the colour in the foreground (above), and finally to tidy up the edges and give some shape to the boulders on which I was sitting (see pages 110–111). This involved the use of a watery mixture of the background tree colours and a little ultramarine to reflect the sky colour. These were pulled downwards onto the river area and then, before they had time to dry, a little clear water was dropped onto the area

nearest the bottom of the picture to create a fade-out of the reflection.

The shape of the centre column of the bridge was left clearly visible in the reflection to give a sense of shape to the reflection of the bridge itself.

As soon as this was fully dried, a few scratches were made horizontally across the river (see page 107) with a very sharp object to give the impression of reflected light.

Stone Bridge

Areas of white paper left in the painting can enhance the feeling of light and reflection

Mirror images are rare. Most water moves or flows to some extent and is best captured by free brush strokes using a medium brush and much water

Reflections from objects on the far bank of a lake or river will usually appear to become lighter towards the bottom of your picture. In these areas colour can be washed out by blotting with kitchen paper

SEA AND SKY

*The vast expanses of open seas and skies are sights that
are usually only available to seafarers. The seascapes
that the majority of us witness are surrounded by land or
harbour walls, or cluttered by masts and jetties and assorted
man-made structures.*

The combination of expansive skies and
stretches of sea are usually painted with a
variety of blues as a working base, although
skies and seas are rarely composed of pure,
unadulterated blue. For this reason I have
chosen to work onto blue tinted paper (see
pages 14–15) for the paintings in this
section, taking full advantage of the ready-
made blue base – the only disadvantage
here is that you cannot use the background
colour of the paper to achieve highlights in
the way that white paper permits, so you
will have to think in terms of blue
highlights instead.

Cobalt blue

Ultramarine

These two examples illustrate the ways in which the same colours react with tinted paper. The cool cobalt blue which was used for the middle tones in the clouds appears to be much more prominent when applied to the blue paper. The ultramarine, however, when applied to the sky area directly behind the cloud takes on a stormy feel, replacing the gentle, warm feel that it imparts when painted onto white paper.

The key lesson to be learned from these examples is that when painting onto any

Cobalt blue

Ultramarine

type of tinted paper, stick to a scene that will only require colours from within the appropriate colour family – there would be little point, for example, in attempting to achieve a vibrant orange using blue paper as the translucency of the medium will always allow the cool blue to show through, deadening the effect of the brightness. The colours best suited to blue paper are blues, greens and browns – all colours that sit easily, or mix naturally, with blue.

The bottom line here is that blue paper will give a cool feel to your picture. But when you know that, you will be able to make more informed choices about the type of paper that you use and marry this with your personal painting requirements.

It is, as always, worth experimenting with different papers as they can act as a ready-made underwash, allowing you to spend a little more time getting the exact colours that you want mixed in your palette – and you do not have to wait for it to dry, either!

FISHING BOAT REFLECTIONS

*T*inted paper was a particularly natural choice here as a base onto which to work at the quayside when this rusty old fishing boat sat basking in the midday sun. There was little breeze and, as a consequence, little movement on the water, allowing for a more clearly defined reflection than would be found with a full-flowing tide.

Most structures – buildings, bridges and boats (of whatever size) are usually started with an element of drawing – and this boat was no exception. Only the boat was drawn, however. Any attempt to create pencil guidelines for the reflection could have resulted in a painting that was unnaturally inhibited – a free flow of paint is always required in these cases.

Having sketched in the basic shape of the boat and its assorted structures, it was time to get to work on the painting. The basic colour of the boat and the water was cobalt blue and this was applied freely to the entire area using a medium brush, but not too much water. (It is important to remember that tinted papers are only produced in quite light weights. In practical terms this means

that they will only stand up to a limited amount of wet-washing.) When the cobalt blue underwash had dried, a layer of ultramarine was painted carefully around the bottom of the boat to act as the darkest part of the reflection.

As it is colours that reflect, creating the shapes, the next important stage was to make sure that the rusty metal structures of the old boat were reflected in the gently lapping salt water. This was done while the ultramarine was still damp so as to encourage a level of bleeding. A small brush was used to drop the brushload of burnt sienna (the most reliable rust colour that I know) onto the appropriate areas and to pull the paintbrush in a vertical direction down towards the bottom of the picture.

The deepest, darkest blues are usually found directly underneath the object creating the reflection

Reflections of rust are created by dropping burnt sienna onto damp paper and pulling downwards

Reflections on water can often appear as a combination of positive and negative shapes. Linear reflections are 'drawn' with a paintbrush

Fishing Boat Reflections

Early Morning Estuary Step-by-Step

1 The first stage of production when confronted with a complex vista of sky, water, banks, boats and jetties such as this, is to establish a basic structure upon which to work. So, a pencil drawing picking out the key features is a very good starting point. Having completed this, the first act of painting was to establish the sky colour as this would set the overall tone for the entire scene. The very pale, early morning sky was painted using a medium brush and a wash of cobalt blue for the medium-cool tone that this gives on tinted paper. An even thinner version of this was then used to establish the basic colour for the water in the estuary.

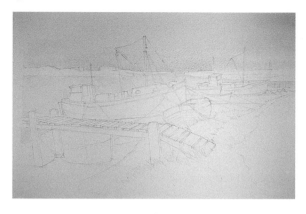

2 The next stage was to use this blue to establish the background tones on the river banks along the horizon. To achieve this, a little sap green was added to the blue tones still in my palette lid and washed along the areas representing the grass. I also used this opportunity to finish off the remaining blue in the lid to paint an underwash onto the few colours that appeared on the boats alongside the banks.

3 When the paint had dried, I felt it was important to introduce an element of form into an otherwise flat composition. To do this I mixed some ultramarine with sap green and, using a small brush, painted this onto the darker areas of the grassy river bank. Before this had time to dry, I returned to my medium brush and, using a little clear water, pulled the paint upwards towards the top of the grass.

I also set about establishing an element of tone on the boats by using the same ultramarine to paint in the shadows on the bottoms or sides of the wooden hulls.

4 When this was completed, the picture was starting to take shape, literally. The next stage was to paint in the main feature of the scene – the centre of focus – the rusting hulk of the old coaster.

One of the most important visual features of this was the number of mooring ropes which criss-crossed the foreground. To work effectively, these had to be kept in negative and this involved carefully painting behind the ropes, allowing them to stand out against the dark colours of the boat. Having painted the ropes in this manner, it would have proved extremely difficult, if not impossible, to paint the main body of the old coaster using horizontal brush strokes.

Fortunately, the vertical rust streaks on the hull of the vessel meant that vertical brush work was, in any event, much more appropriate here.

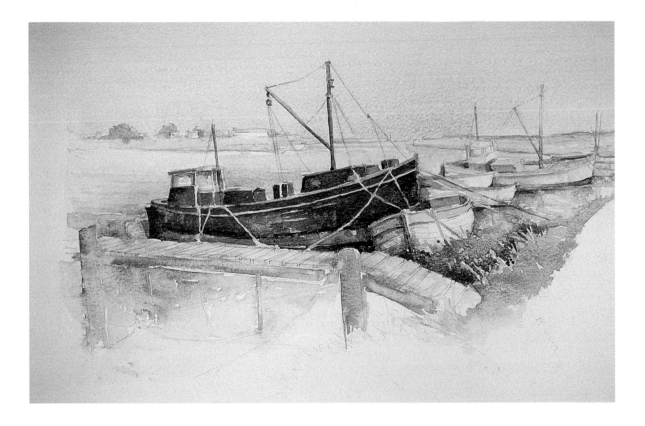

5 The penultimate stage was to establish the base upon which to create the wet, muddy, weatherbeaten feel that was so much a part of the scene. This involved painting the jetty with an underwash of raw sienna using a medium brush and then, using the same brush, pulling the colours of the jetty and the foreground boat down onto the area underneath the structure where the cold, wet mud lay.

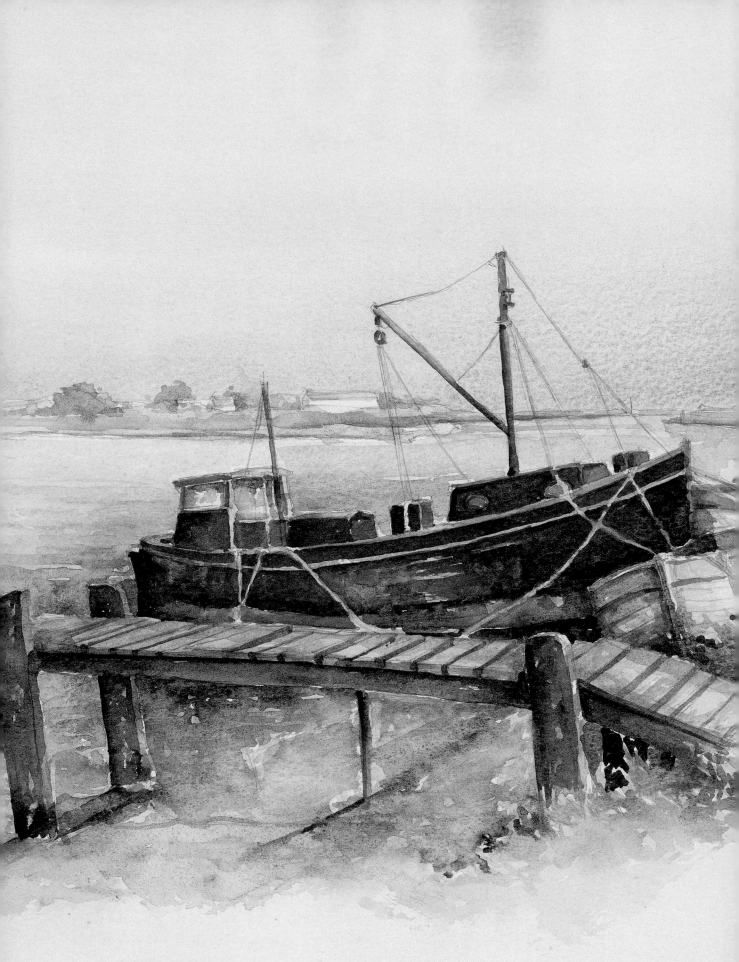

Early Morning Estuary

6 The final stage was to create 'wet' shadows. These had to be painted onto damp paper so as to prevent any hard lines occurring. This involved dropping successive watery amounts of ultramarine, burnt umber and raw sienna onto the area directly underneath the jetty and allowing these colours to bleed and flow freely. As they dried they left a muddy, uneven feel to the foreground.

The picture was completed by adding the sharp shadows to the wooden structure of the jetty in marked contrast to the muddy sinking surface upon which it was precariously balanced.

The early morning view of this sleepy estuary was awash with blues: the soft sky, the distant horizon, the near motionless water and the cool shadows all required visual underpinning with blue tinted paper

FINAL THOUGHTS

Watercolour and nature are good allies – they are both easily accessible, capable of subtle, yet fiery, appearances and, to a greater or lesser extent, are ultimately outside our physical control.

Having reached the last few pages of this book, it is time to reflect on some of the techniques examined and the issues raised.

Now that you have worked your way through the techniques – wet-into-wet, dry brush, textures and so on – you will doubtless be aware of the vast potential of watercolour paints. They are considerably more than a beginner's or amateur medium, and the great advantage that they have over most other art media (with the possible exception of pencil drawing) is that they are so portable that they can be taken anywhere – and my strongest advice is that you do. You do not have to set up a vast array of equipment to enable you to make a few watercolour sketches, so take advantage of this and try to devote a few minutes to sketching in watercolour as often as you can. There will be very few occasions when you will not be able to lay your hands upon a natural object or have access to a window on the world of nature. Maybe a lettuce leaf or an apple in your lunchbox, or a few leaves by your feet in your garden or local park, or even the view from your home, holiday apartment or hotel. All of these can be wonderful subjects and so easy to find. The persistent practiser will very soon become a highly proficient practitioner.

The jump from beginner to competent watercolourist is easy, but not instantly obvious when it occurs. It will not happen on day three of a course, or after so many pages of a book. Everyone will progress at their own rate, and there are no set markers that dictate where you

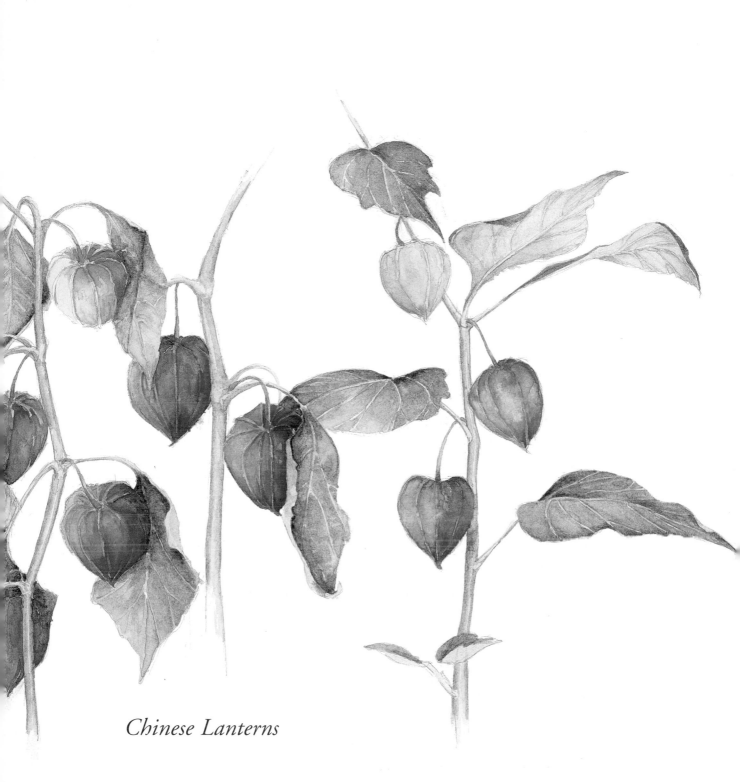

Chinese Lanterns

must be with your skills and technique, or at what particular time you arrive there. It will, however, gradually happen as you become aware that subjects which you once found daunting, you now find fulfilling, and techniques which you once thought carefully about and approached cautiously, you are now applying as if they were second nature to you.

But, having worked through this book, practised and become confident and competent with watercolour painting skills, and

learned to seek out subjects from the natural world, where do you go next? My advice is to seek others in the same position as yourself, and this will generally be achieved by joining (or even by forming) an art club or society. I spend much of my time talking and demonstrating to such clubs and societies and have, without exception, found them to be the most welcoming of places. They are, invariably, composed of like-minded people who usually share a common aim – to thoroughly enjoy their art. Local libraries will usually hold the contact names, addresses and telephone numbers, so do seek them out.

A final thought now on the subject of the natural world. As a painter I have learned, as I hope you will also, to find beauty and inspiration within the natural world that we inhabit. I have also learned respect for it. Nature is a thing of great wonder to artists and scientists alike, and we have both learned to control some of its elements and to admire those elements that we cannot. Perhaps we can also learn to repay nature for its sources of inspiration by taking care of the natural world – as artists we are as much its custodians as any others. But as artists, we provide many windows on the world of nature through our painting, and are therefore in a position of influence.

Enjoy your painting.

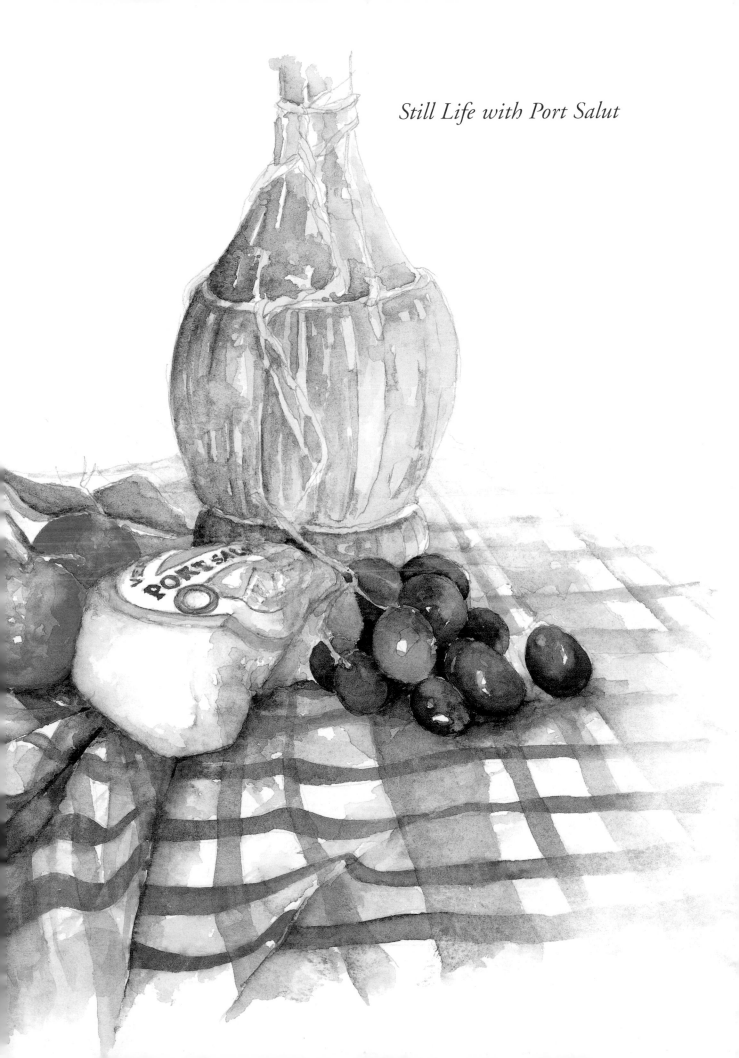

Still Life with Port Salut

GLOSSARY

BLEEDS The running or diffusion of colour which occurs when wet paint is moved across the surface of paper, usually by another application of water.

BLENDING Combining, with an element of control, of two or more colours to create a distinctive, clearly defined paint.

BLOCKING IN The filling of an entire shape with flat colour (i.e. without particular concern for light or shade).

COCKLING Buckling of paper which occurs when too much water is applied to lightweight paper too quickly.

COLOUR TEMPERATURE The impression of heat or cold which any given paint imparts.

COMPLEMENTARY COLOURS Colours that are on exact opposite sides of a colour wheel (e.g. red and green, yellow and violet), and that produce a striking visual effect when placed next to each other.

COMPOSITION A term used by artists to describe the way in which they place their subjects on a sheet of paper.

DRY BRUSH A technique which involves painting with minimal amounts of water although, of course, a certain amount of water is required to produce watercolour paint.

FORM An appearance of three-dimensions created while painting, making an object look as if it has mass.

GRADUATED SHADING The gradual change that occurs on curved objects as the shading changes from dark to light.

LOADED BRUSH A brush holding its maximum capacity of water, or watery paint.

NEGATIVE SHAPES Shapes that appear either white, or particularly light, when viewed against a dark colour directly behind them.

POSITIVE SHAPES Shapes that stand out by themselves, usually dark shapes placed in front of a light background.

'PULLING' PAINT A particularly positive brush stroke in which water or paint is brushed away from a specific point.

PUSH-PULL EFFECT A visual illusion created when one colour is used to visually 'push' another colour forward.

RUNS These occur when wet paint is moved across the surface of paper, usually by another application of water.

SCRATCHING A useful technique to suggest highlights on water by scratching lines onto dry paper, exposing the fibres of the paper.

TINT A very pale, barely discernible colour wash.

TRANSLUCENCY The main quality of watercolour paints – clear, but only partially transparent.

UNDERCOAT/UNDERWASH The first application of watercolour paint onto blank paper.

WASH The application of either paint or water in fluent strokes.

WET-INTO-WET A technique which involves applying wet paint to a wet or damp sheet of paper, causing the paint to bleed outwards.

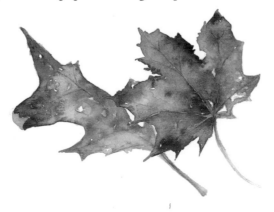

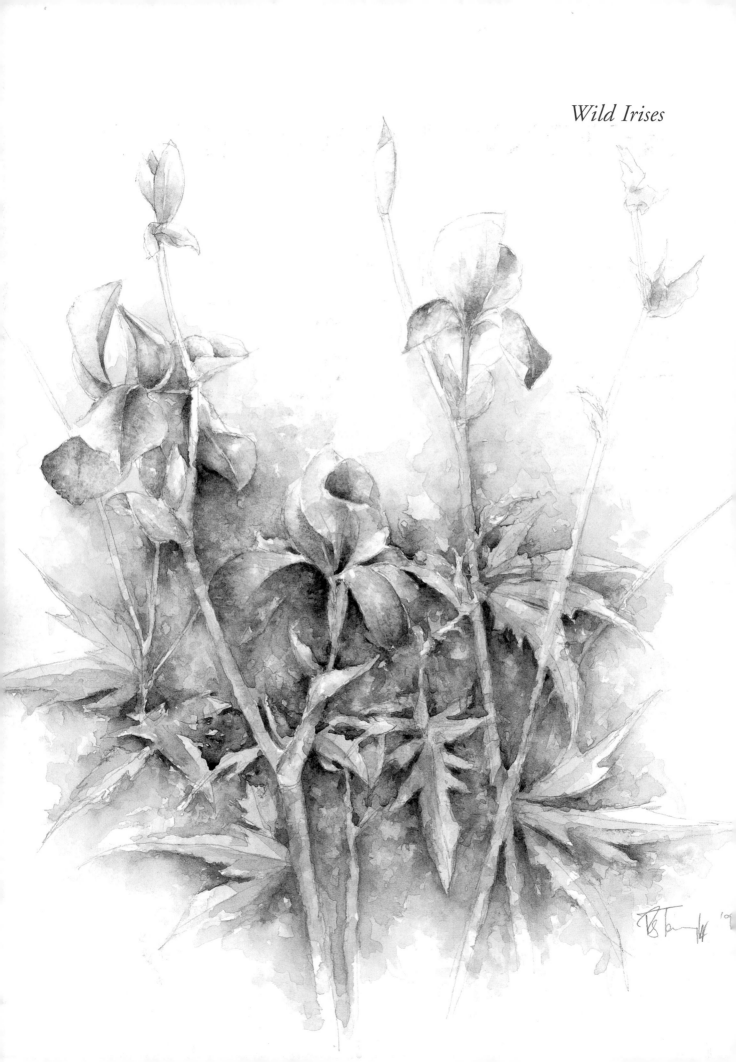

Wild Irises

ACKNOWLEDGEMENTS

In considering those who warrant acknowledgement in the making of this book, my immediate family spring instantly to mind. The constant questioning, ready praise and criticism from my young son, Edward, has kept me alert and mindful of any level of pretension. My wife, Debbie, has throughout taken on the role of secretary, proof-reader, valued critic (my home is full of them!), sub-editor and post-mistress and, in so doing, has been instrumental in holding the entire project together. Also the gifts of brushes, paints, canvases and easels that my parents gave to me as a child are never far from my mind – but their gift of encouragement was even greater, and more highly valued today.

Finally I do wish to acknowledge the role that my agent Amanda White has played in creating this book. Her belief in the project from the outset has been of great importance to Debbie and myself, and this has allowed us to give our full concentration to the creative aspects of putting this book together.

INDEX